NEWCASTLE EAST
THROUGH TIME
Darren W. Ritson

AMBERLEY PUBLISHING

Acknowledgements.

My father, Walter Ritson, for access to and use of his wonderful photograph collection; without these images this book would not have been possible; thanks dad. To my mother, Jean Ritson, for the use of one picture from her family archive. Newcastle Libraries and Information Service for use of the rest of the images contained herein. Massive thanks to Amberley Publishing for the enormous amount of help and support they give me during the compilation of this book. To Sarah Parker for her help and assistance and to everyone else that has played their part in helping me put this collection of old and new images together.

This book is dedicated to my father, Walter Ritson;
Without his work this book would never have been compiled.

First published 2012

Amberley Publishing
The Hill, Stroud
Gloucestershire, GL5 4EP

www.amberley-books.com

Copyright © Darren W. Ritson, 2012

The right of Darren W. Ritson to be identified as the Author of this work has been asserted in accordance with the Copyrights, Designs and Patents Act 1988.

ISBN 978 1 4456 0062 8

British Library Cataloguing in Publication Data.
A catalogue record for this book is available from the British Library.

Typeset in 9.5pt on 12pt Celeste.
Typesetting by Amberley Publishing.
Printed in the UK.

Introduction

Putting together a book like this one – for me personally – was quite an easy and a very much enjoyable task largely thanks to my father, Walter Ritson, who for the past thirty to forty years or so has been taking photographs of his beloved Newcastle upon Tyne, moreover, his native East End. Born and bred in Carrack Street in Byker my father has spent all his life pacing the streets with his Nikons and his Minoltas, his light meters and his spare rolls of 200ASA black and white film, documenting the area as it has changed constantly throughout the years. I always remember as a young boy growing up always seeing my father with his camera around his neck. Most of the time he was out working or taking his pictures and when he *was* at home, he was in his dark room developing his work. But it wasn't just landscape photography and general scenes of Tyneside that my father immortalised on film; it was real life too; real people; real memories of Tyneside.

I was born in the General Hospital in Newcastle and like my father I was raised in the East End of Newcastle, in Walker, and never left the area until I was in my early thirties; and then I only moved a few miles east to Howdon in North Tyneside. My father still resides in Walker and to this day he still paces the streets of Newcastle east taking his photographs. We lived in a modest semi-detached house in the St Anthony's area with my mother Jean, and my brother Gary. Back then, in the early days, times were tough and the area which we lived immediately adjacent to was well known throughout the good folk of Walker to be a place that *most* people would choose not to live, and that's putting it mildly; I am referring to Mcutcheon Court. Smashed windows, boarded up doors, burglaries were rife, rubbish was strewn all over the place and stolen cars were often dumped and set on fire there, and that was its good points! But like most families and folk in this area, we just got on with it and if somebody ever asked me today if I could go back and change anything then my answer would be a resounding no, and I mean that sincerely. You see, people from that neck of the woods, the Walker lads, were, and still are, the salt of the earth and it was being brought up with these people that have made me the person I am today. Although I have relocated, I will always know where my roots are and still hold in my heart fond memories of my upbringing.

Nowadays, the area where I grew up is known as 'Rivers Gate' and it has been massively transformed with the nine tower blocks of Mcutcheon Court being completely demolished and in its place a lavish and luxurious housing estate was built; out with the old, in with the new. The homes in the neighbouring Bakewell Terrace and The Oval, were also extensively

modernised on the exterior to 'fit in' with new look Rivers Gate which was in itself, an extension of the massive quayside development that included the magnificent St Peter's Marina which was built on the massive site of Hawthorn Leslie's east end premises. As we shall see in this book, the quayside development stretches all the way to Newcastle Quayside some one and a half miles west up river. Sadly, not all the houses in my old neck of the woods survived to tell the tale as 'the back lane' was demolished with *all* the houses and shops on Walker Road, as was the Birds Nest public house and the nearby club that shared its name. Although it was very sad to see these go, it was refreshing to see the new coming in. What we have nowadays is, in effect, tomorrow's history with yesteryear's history now being preserved in people's memories and in photographs, some of which are included in this book.

Whilst planning the compilation of this book I had much to think about in the respect that I was torn between my sources for the images. Should I compile a *Through Time* book similar to the other fantastic and well put together volumes that consisted of brilliant old library images largely dating from the late 1800s to the early 1900s as well as their modern day equivalents? Or should I try something new and different and compile a volume that dates back only to the late 1960s or so and focus on that particular timeline onwards? The idea of *both* really appealed to me and because I could not make up my mind, I opted to do just that, both.

Around half the images in this book are from my father's collection which date back from the late 1960s to the early 1980s. A lot has changed between then and now and this book of wonderful photographs will illustrate quite nicely just how quickly, we, as humans, progress and move on in an ever developing world. Another great advantage of raiding my father's wonderful picture archive is that for the best part of forty years, they have *never* been seen by the public; in fact I know of certain members of our own family that have not yet seen them. As long as I can remember they have been sitting in his cabinets at his house in Walker, not gathering dust – I might add – but carefully packed away in air tight plastic bags and in boxes. That was until I decided to dig them out. The rest of the 'old fashioned' images produced herein were sourced from Newcastle City Libraries and they take the book back as far as the late 1800s to the early 1900s. Here is a wonderful selection of images that displays Newcastle East quite aptly as the book title suggests – through time. I hope you agree.

Darren W. Ritson, 2012

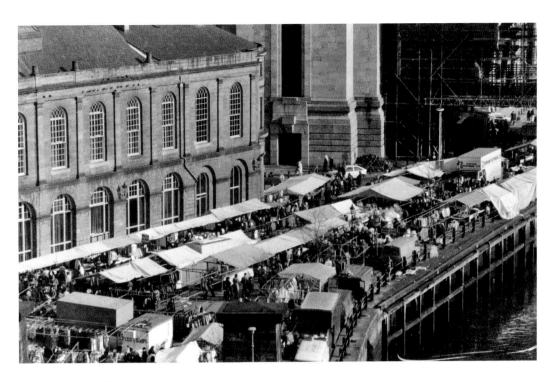

The Quayside Market

Sunday morning back in the early 1970s, quite a difference to what we see today. In this old image the quayside is cram packed with folk from all over the North East of England – and beyond I dare say – all looking for a bargain. (Old image courtesy of Walter Ritson)

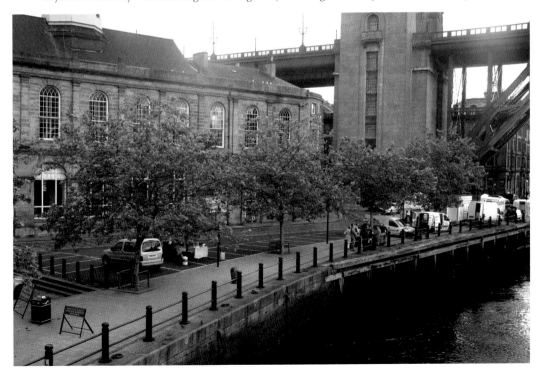

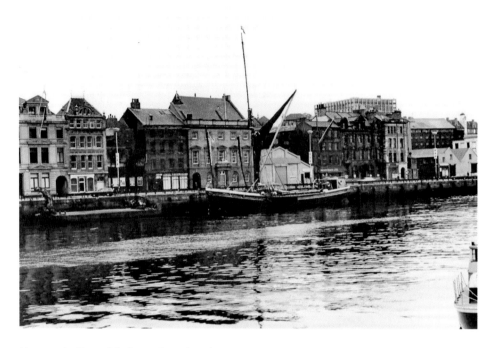

Newcastle Quayside from Gateshead

Back in the days when it was a very lively and sustainable waterfront. The old image we see here shows Newcastle Quayside in 1972 long before the commencement of the quayside redevelopment scheme. The newer image shows the magnificent law courts that were built between 1986 and 1990 on the site of old factories and warehouses that once stood there. The quayside has now been drastically redeveloped for art, music and culture and is now one of *the* 'must visit' places in the UK. (Old image courtesy of Walter Ritson)

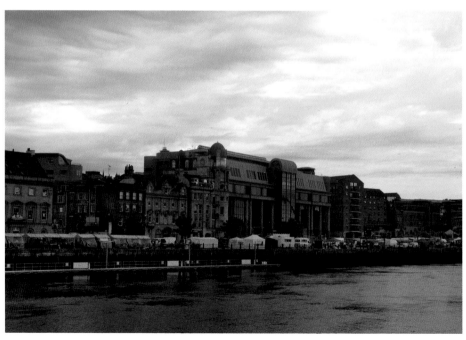

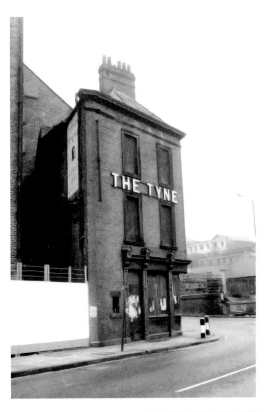

The Waterline, Quayside
From an old pub to a new modern trendy joint which today still serves the good folk of Tyneside with ale and beer. Consuming alcoholic beverages on the quayside has become commonplace and many establishments are more often than not opening their doors to revellers from across the region. The Tyne, as this old pub was once called, was rescued and given a new lease of life. Today it is known as 'The Waterline'. (Old image courtesy of Walter Ritson)

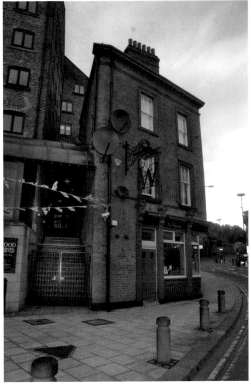

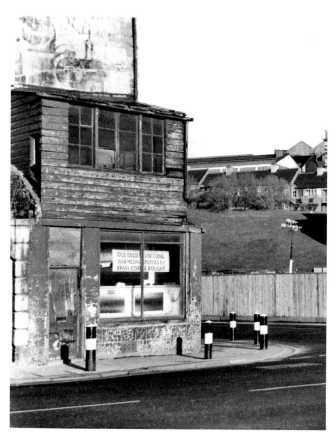

The Law Courts, Quayside

Where the quayside meets Broad Chare. In the old image a shabby wooden shack of a store that once traded gold coins, war medals and pistols. Over the road lies empty fields and wasteland which was destined for greater things. Fifteen years after this old image was photographed, the building of the magnificent law courts began. (Old image courtesy of Walter Ritson)

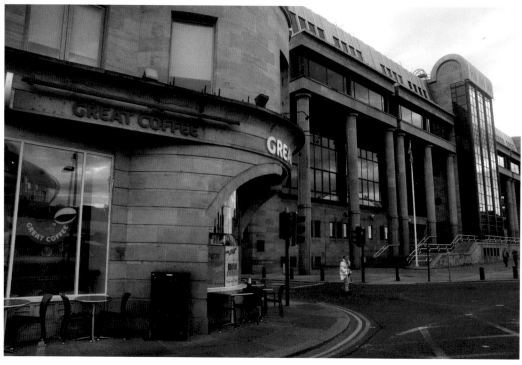

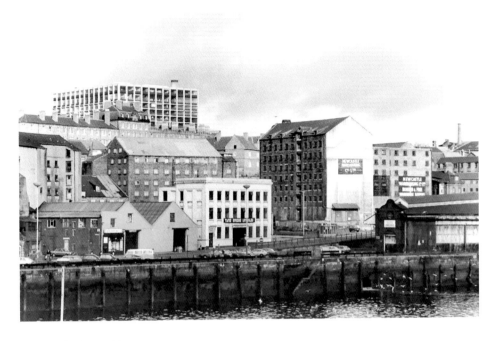

Newcastle Quayside

Most of the buildings in this old image from 1972 are now confined into the realms of history. The sheds on the quayside, the factories and warehouses, garages and other such buildings are gone forever. One or two edifices remain today, however, as modernised private flats, accommodation and a pub or two. (Old image courtesy of Walter Ritson)

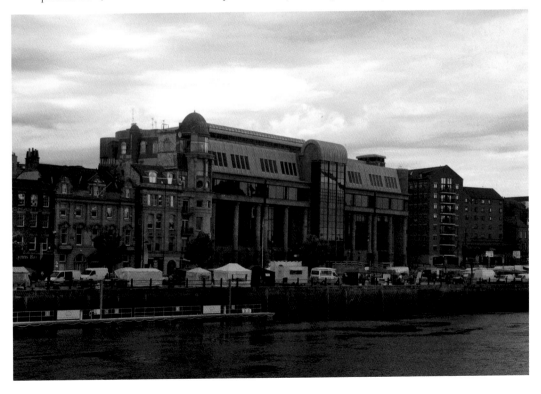

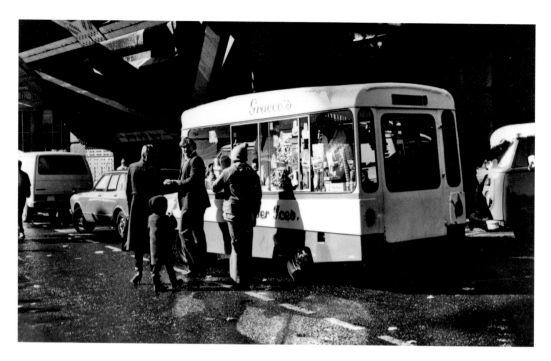

Ice Cream – Tyne Bridge

A 1970s family having their Sunday morning ice cream from one of the many ice cream vendors that frequented this area under the Tyne Bridge. The modern picture shows vendors plying their trade – again under the Tyne Bridge. It was hot dogs and ice creams in the early '70s; I doubt back then they would have had pork and apple stuffing sandwiches, or curly fries. (Old image courtesy of Walter Ritson)

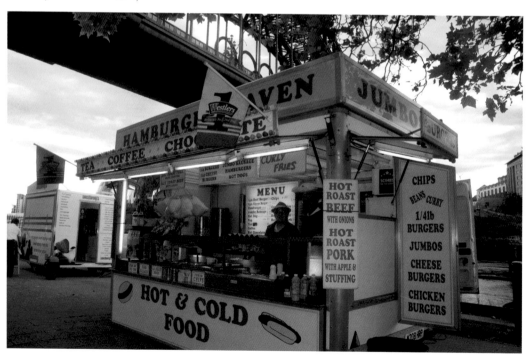

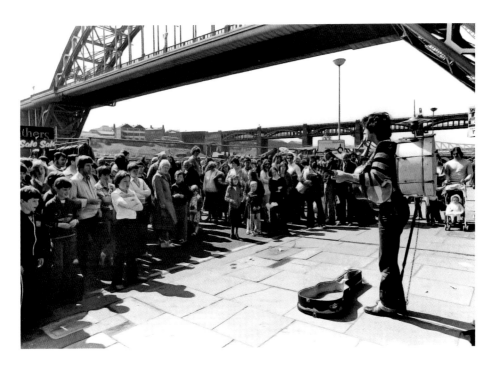

Buskers and Street Entertainment, Quayside

In this old snap a one man band entertains the masses on Newcastle Quayside; you don't see many of them these days. Nowadays more modern buskers and street entertainers play to audiences with electric guitars, plug in acoustic guitars and amplifiers. The Mac-Set Project are just one such band that are made up of father and son and play fantastic cover versions of hits such as 'Wonderwall' by Oasis, 'Hide Your Love Away' by The Beatles, and 'Meet Me on the Corner' by Lindisfarne – a famous North Eastern band. (Old image courtesy of Walter Ritson)

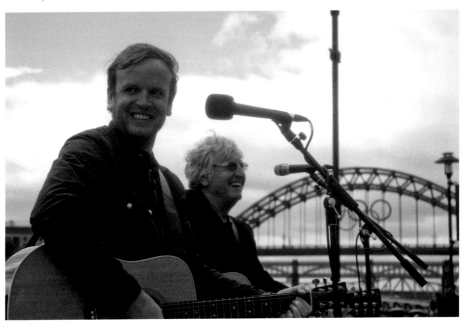

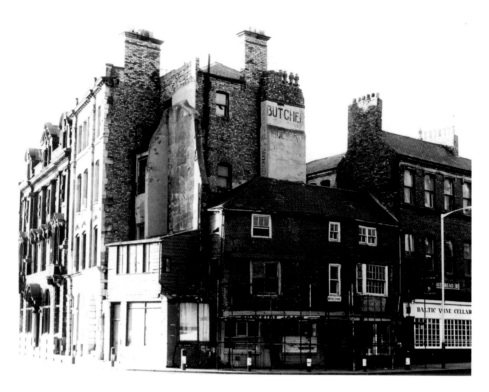

Broad Chare, Quayside
Back in early 1970, the old war medal shop that featured on page 8 can be seen from a different angle. The law courts are to the immediate right of the image with the newer of the two images showing, in full glory, the offices and private dwellings that replaced these old and tatty buildings. (Old image courtesy of Walter Ritson)

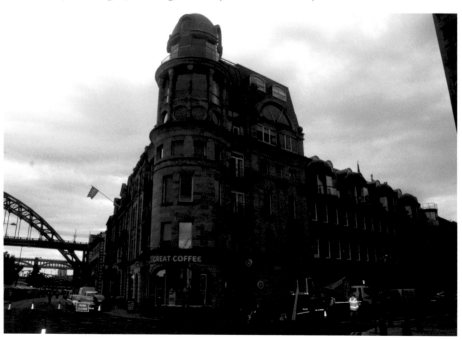

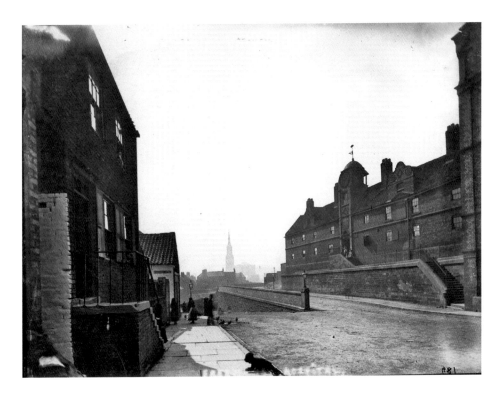

City Road near Pilgrim Street

On the older of the two images, *c.* 1880, and to the right, the Keelmans Hospital can be seen which was built in 1701/02 and housed some of the poor and ill folk of Newcastle. Nowadays, it is said that the former hospital is used for student accommodation. All Saints Church can be seen in both images at the centre rear. (Old image courtesy of Newcastle Libraries and Information Service)

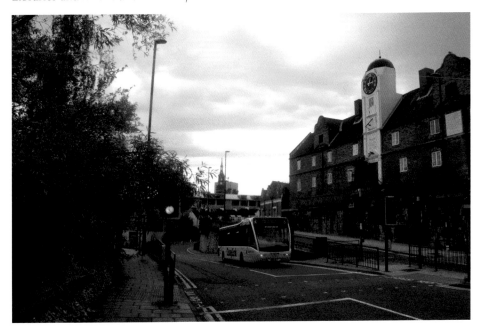

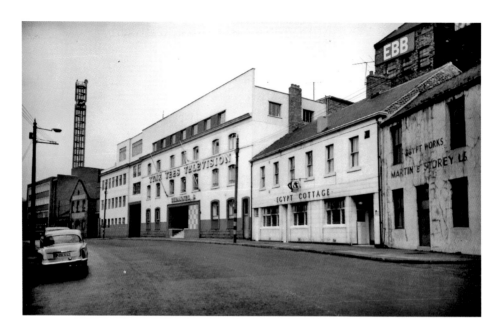

Tyne Tees Television on City Road

Launched in 1959 after it had been converted from two old warehouses. The four TV studios at City Road broadcast many wonderful news and current affairs programmes such as *Northern Life*, and led the way in pop music programming with line-ups such as *Razzamatazz* and *The Tube*. In the older of the two images you can see the pub known as the Egypt Cottage which was nicknamed 'Studio 5' by employees after spending so much time in there. Martin & Storey Ltd, to the right of the image, was later demolished so a real Studio 5 could be built. A long tube-like entrance led to the back of the Egypt Cottage pub where Studio 5 was situated. Nothing remains of the site nowadays and as far as I know no plans are set to build on the former TTTV site. (Old image courtesy of Newcastle Libraries and Information Service)

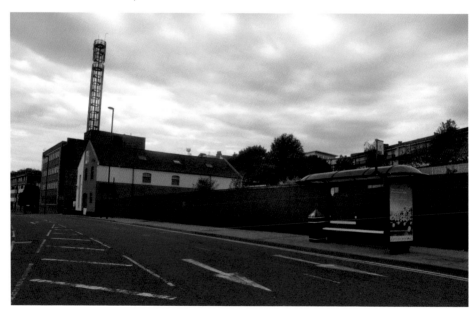

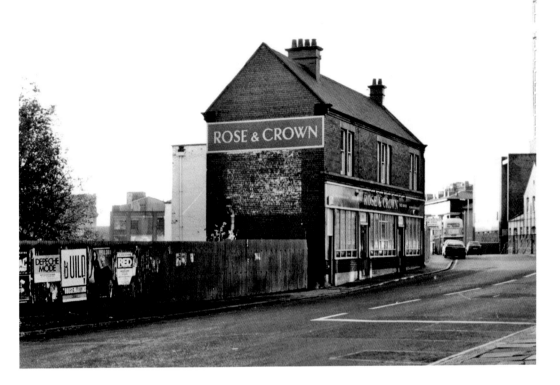

The Rose and Crown Pub, City Road

Located across the road from TTTV and the Egypt Cottage on City Road. This pub, which came down around 1980, made way for a brand spanking new swish health club before it was transformed into the office blocks we see today. (Old image courtesy of Walter Ritson)

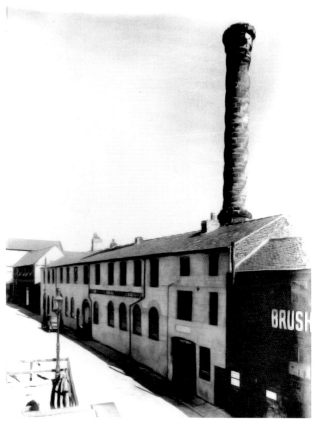

St Ann's Street Ropeway

The old image depicts the rope works on what was known as St Ann's Street. Interestingly, the tall chimney stack was deliberately engineered to look like a long piece of hemp, signifying what was made there. Nowadays, as you can see on the newer image, the road houses lavish and stylish accommodation which is part of the massive quayside restoration project. (Old image courtesy of Newcastle Libraries and Information Service)

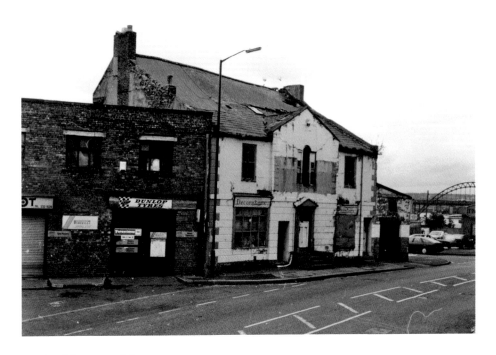

Destined for Demolition

These are the old garages and decorators' stores that once stood on the corner of City Road where it meets Cut Bank. The decorators' store was at one time the family home of the owner of the aforementioned rope works factory down on St Ann's Street. Interestingly, the buildings were demolished the day *after* the old image was actually taken. Towering almost 50 feet high, the new lavish apartments that face the river command spectacular views of the city and of course the redeveloped quayside. (Old image courtesy of Walter Ritson)

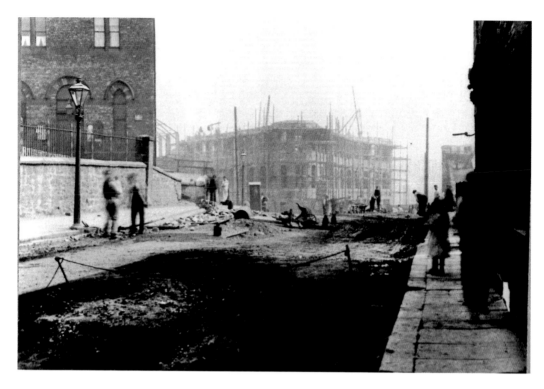

Cut Bank/Walker Road

The only building left standing in this old image is the old church on the left hand side of the picture which is now a private residence. This image dates from around the late 1800s and shows City Road leading to Cut Bank. Nowadays, the road off to the right leads to Walker Road with the road to Cut Bank still being used today. (Old image courtesy of Newcastle Libraries and Information Service)

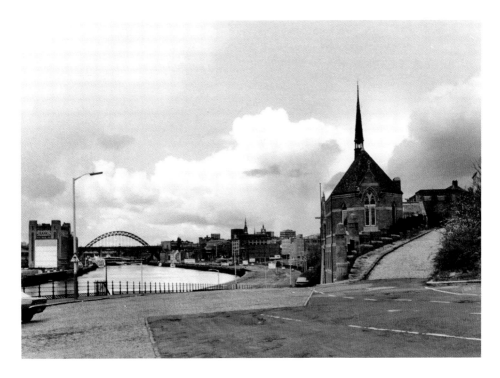

The Sailors' Bethel, Haratio Street

This is an old view of Newcastle Quayside taken from Horatio Street around the mid-1970s. The one time wooden huts that adorned the quayside have been demolished making way for the new offices and flats that were to be built there some time later. The cobbled road leading off to the right is called Tyne Street and, as the new image shows, its entrance has been subsequently blocked off with a wall. The church building is known as the Sailors' Bethel and was pained by L. S. Lowry in 1965. (Old image courtesy of Walter Ritson)

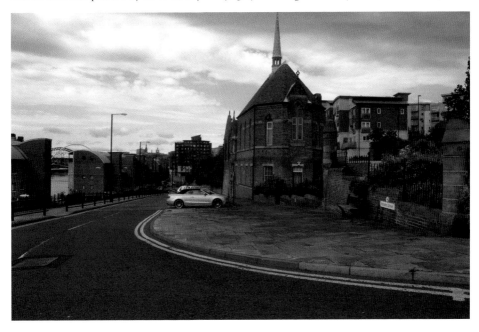

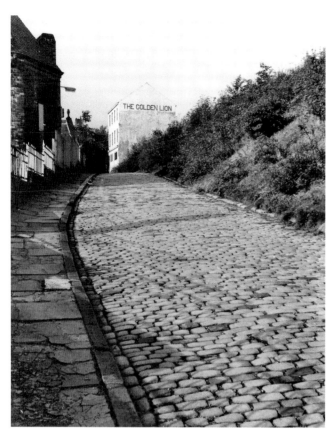

Tyne Street
The old cobbled lane known as Tyne Street running up to the now long gone public house called the Golden Lion. In the modern image one can see the back of the private apartments that stand on City Road. These take the place of the old pub. The old church on the left is known as the Sailors' Bethel; it was designed by Thomas Oliver and opened in 1877 as a chapel for seamen. (Old image courtesy of Walter Ritson)

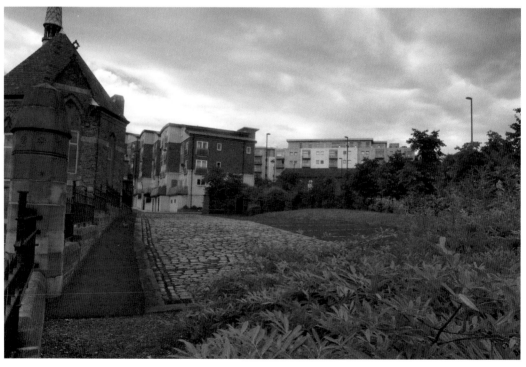

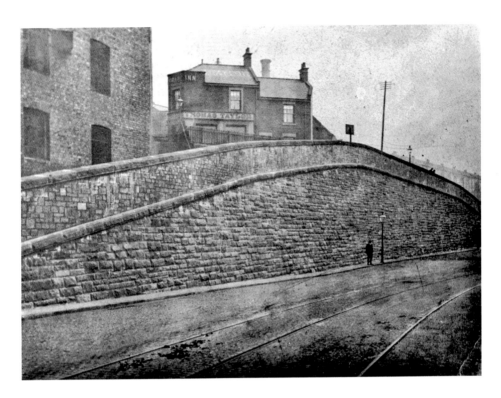

The Free Trade Inn

One of the most charismatic ale houses in Newcastle East. The pub has been serving fine ales and beers as long as I can remember and is often frequented by the local student population. The warehouse on the left of the old image is now gone with nothing more than grass and wasteland taking its place. Cars now use the roads where once quayside trams would operate. (Old image courtesy of Newcastle Libraries and Information Service)

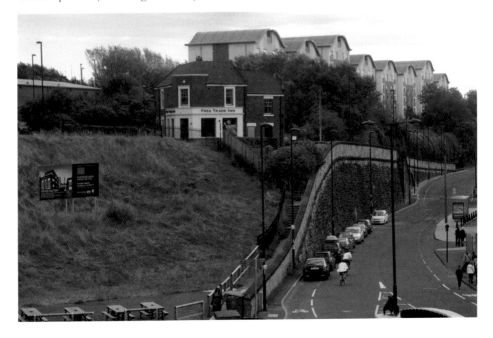

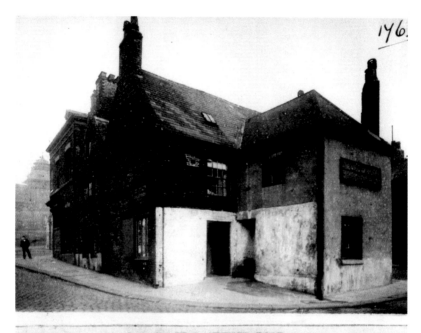

176.

1 & 2, ST.LAWRENCE ROAD.

(Defective brickwork of walls. Cemented walls very damp.)

St Lawrence Road

These wonderful old edifices were once homes back in the late 1800s but were eventually demolished to make way for a pub called the Rose and Crown. Nowadays, more lavish flats and accommodation occupy the site. (Old image courtesy of Newcastle Libraries and Information Service)

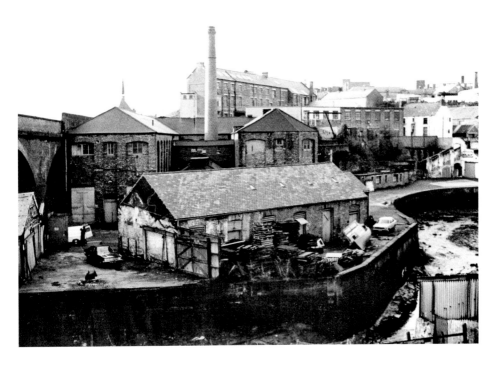

The Gateway to Ouseburn – Commercial to Culture
Known as the 'cradle of the industrial revolution on Tyneside', the Ouseburn, thanks to countless regeneration projects, is once more becoming a great place to frequent. As the home to business, music, art and literature, this one time hub of industry is fast becoming a place of real interest with an absolutely fascinating historical and industrialised past. The older image shows Maynard's Wine Gums Ltd back in 1980. (Old image courtesy of Walter Ritson)

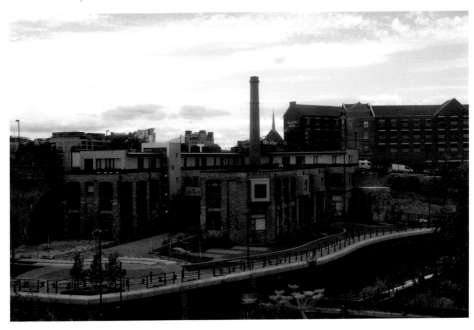

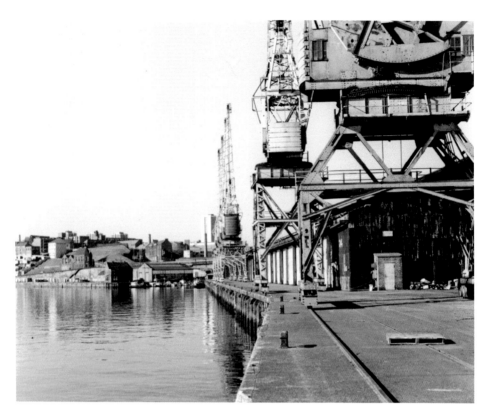

Quayside Cranes – a Thing of the Past

Serving the ships that once docked at this section of the quayside, these cranes and warehouses were dismantled and taken away in the 1980s to make way for a boating club and its car park. (Old image courtesy of Walter Ritson)

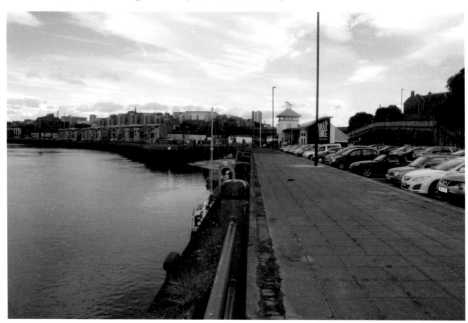

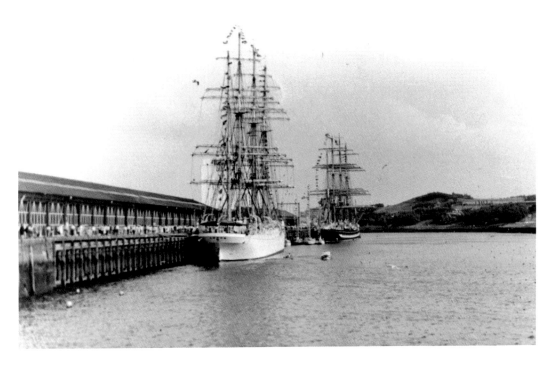

Tall Ships
The tall ships race of 1986 saw millions of visitors descending upon Newcastle East. Boats still moor up along this stretch of the quay but as you can see, they are a lot smaller these days. The wooden sheds and huts are long gone and the quayside development stretches further west down river. (Old image courtesy of Walter Ritson)

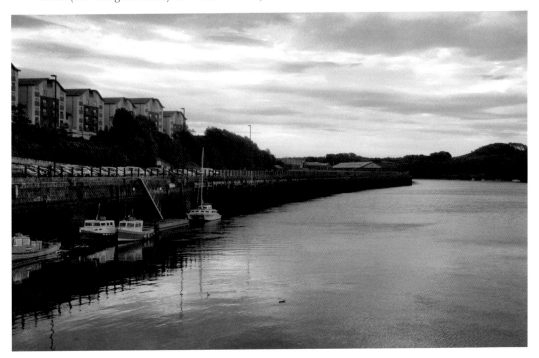

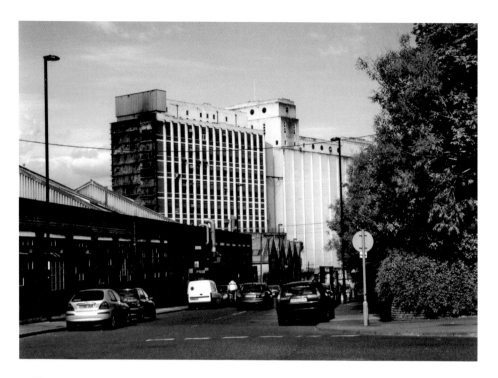

Spillers Mill

From the 1930s until 2007 Spillers Mill was the home of flour production on Tyneside. In its heyday, back in the 1970s, over 500 people worked here. Spillers had come to Newcastle around the late 1800s and acquired these new premises on the quayside in the early 1930s. There were two main buildings, one was the grain store and the other was actual flour mill itself. Demolished by a specialist demolition company, this 120-feet structure was soon relegated to realms of history leaving nothing but a huge legacy in its wake. More quayside redevelopment is planned for its former site. (Old image courtesy of Walter Ritson)

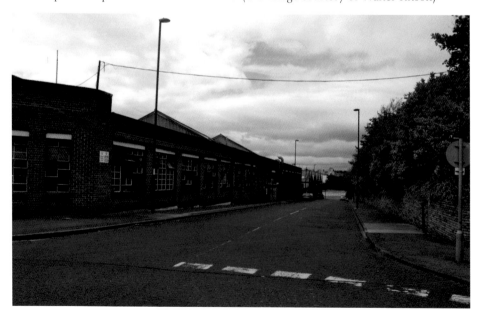

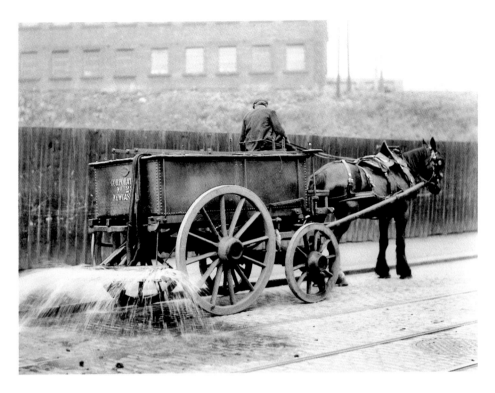

Hoults, Walker Road

Hoults factory can be seen at the rear of both pictures, with the embankment that once housed the Riverside Line that is now part of the Hadrian's Way. The cobbled and tram lined road that is being cleaned by an old style maintenance cart has long since changed with modern tarmac; indeed, the silver Toyota Yaris goes to show how much transport has come on over the years too. (Old image courtesy of Newcastle Libraries and Information Service)

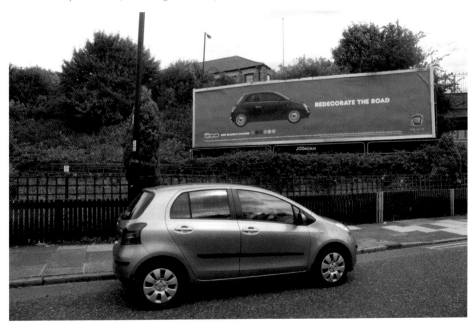

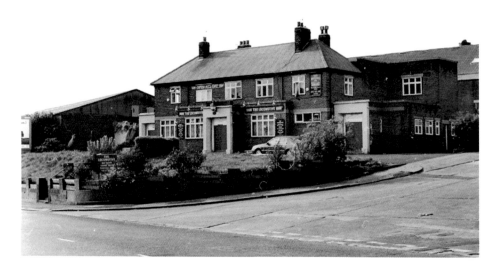

The Locomotive, Walker Road

In one respect nothing has changed here. The pub, known as the Locomotive, was often used by the staff of nearby British Engines after a hard day's graft. Nowadays, after the pub was pulled down in the 1980s, they park their cars here before heading into work. I was once told as a youngster the pub car park was reputed to be haunted by a faceless figure, often spotted by visitors to the pub. Whether it still resides there now remains to be seen, however, but the pub's ghostly memory still remains to those local lads that once frequented its doors. (Old image courtesy of Walter Ritson)

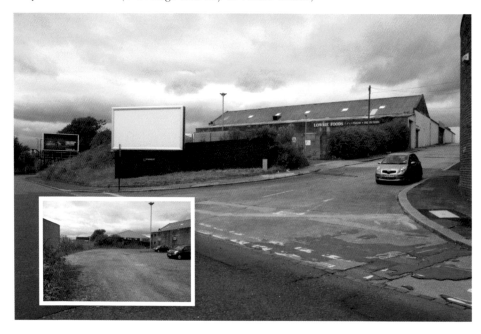

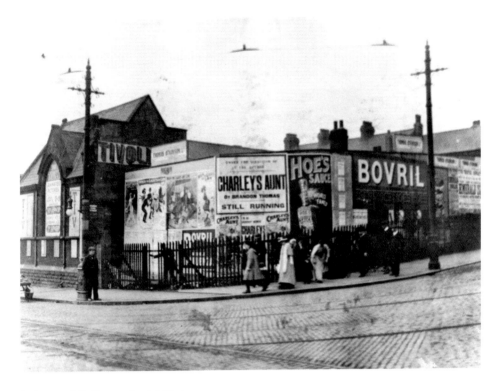

Byker and St Peters Social Club

Nicknamed by locals as 'the bottom club', this social establishment is the working men's club for the Byker/Walker folk. It is one of three in a string of working men's clubs that stretch from Shields Road to the bottom of Raby Street, hence Bottom Club. Prior to this, this corner was used for billboards and advertisement campaigns back in the early 1900s. (Old image courtesy of Newcastle Libraries and Information Service)

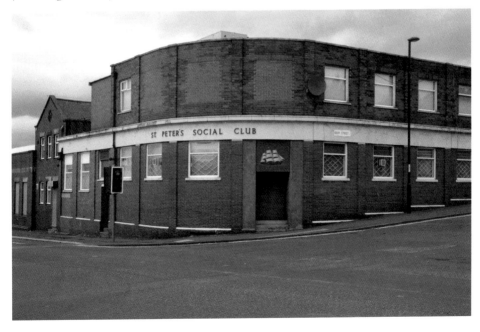

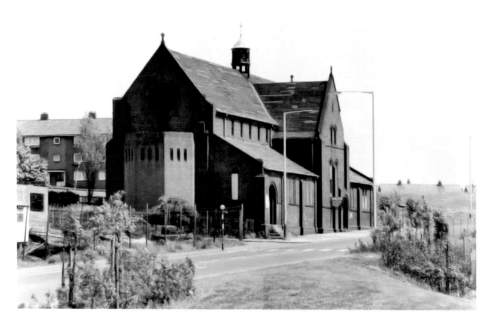

St Peter's Church, Walker Road
Standing very old, derelict, and ready to be demolished. On the site of the old church came new houses which now belong to a new estate. The flats in the left background (Harbottle Court) have also been demolished. These flats got their name from the adjacent park Harbottle Field, which has now been changed to St Anthony's Park. (Old image courtesy of Walter Ritson)

Allotments, Walker Road

Gardeners, pigeon fanciers and vegetable growers would frequent the 'allotment' and spend much quality time away from their wives. These gardens, at the back of Walker Road next to where the Oval is, are an area where the author spent much time as a child in 'Robert's garden'. I spent many an hour helping Robert with his pigeons and if I was really lucky, he'd give me an egg for my collection. Now the allotments here are gone, along with the houses on Walker Road, too. (Old image courtesy of Walter Ritson)

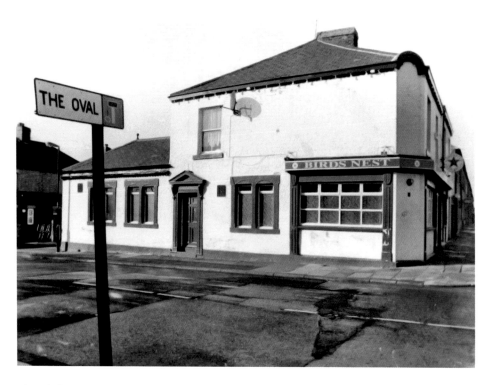

The Birds Nest Pub, Walker Road

Gone, but most certainly not forgotten, the Birds Nest at the top of the Oval on Walker Road. Used by the Walker locals this pub shared the name of a club down the back lane, the Birds Nest Social. That too was demolished to make way for Rivers Gate. (Old image courtesy of Walter Ritson)

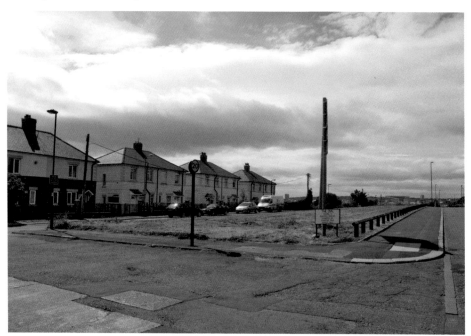

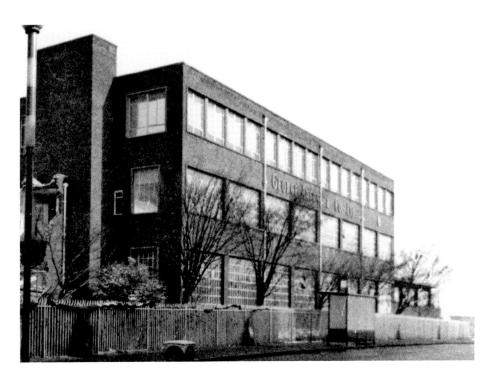

Angus's Factory, Walker Road

The George Angus factory on Walker Road, known as the Angus Gear Works, was founded between 1915 and 1920. It was built by two of George Angus's sons after deciding the Angus Empire, which was originally founded in 1788 on Newcastle Quayside, should branch out and diversify. In 1968 the organisation merged with Dunlop Ltd and by the 1980s the site here on Walker Road was redundant. It was demolished to make way for a new housing estate named Callaly Way. (Old image courtesy of Walter Ritson)

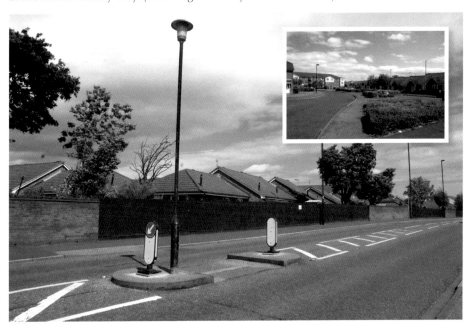

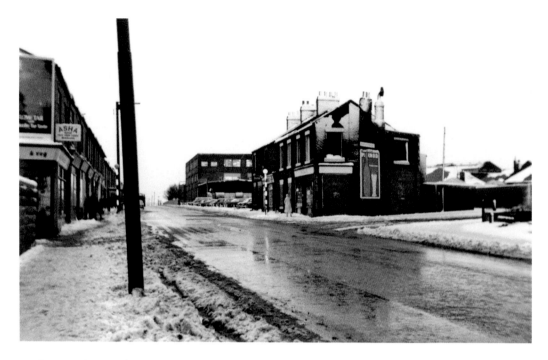

Walker Road, Top of Evistone Gardens
The aforementioned 'Angus factory' can be seen at the back of this old image with the chemist's and corner shops in the foreground on both sides of the road. Just about every building in this image is now gone, except for the building on the extreme right, which is St Vincent's Junior School. (Old image courtesy of Walter Ritson)

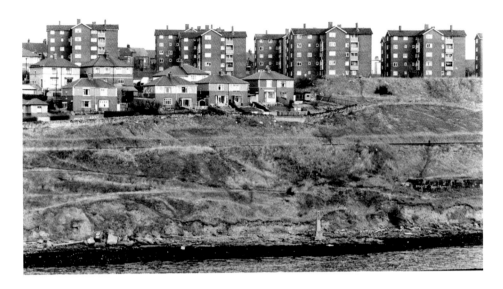

The Oval and Mcutcheon Court

The slum dwellings that were once Mcutcheon Court stand tall as a backdrop to the Oval as viewed from Friars Goose in Gateshead. The old image was taken in 1972 when this area was probably at its worst. Now, it has been incorporated into the quayside redevelopment scheme and a massive restoration has been undertaken. Mcutcheon Court and the Oval are now known as part of the Rivers Gate. (Old image courtesy of Walter Ritson)

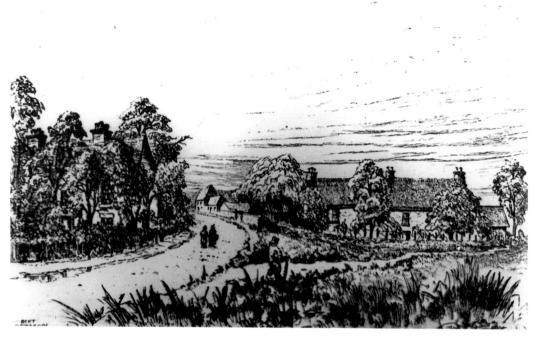

Scrogg Road

This road links Walker Road to Welbeck Road cutting through central Walker. The old picture dates Scrogg Road to the late 1700s and illustrates nicely the difference between what we see today; they say a picture is worth a thousand words and I would say in this instance they are correct. The Walker Park west entrance can be seen to the right of the modern picture. (Old image courtesy of Newcastle Libraries and Information Service)

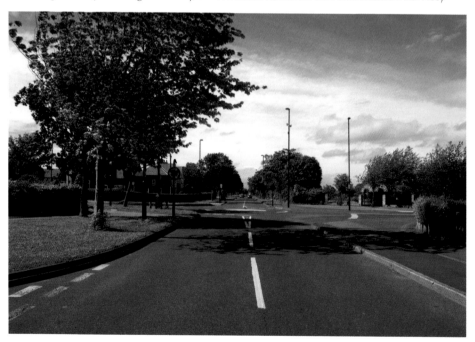

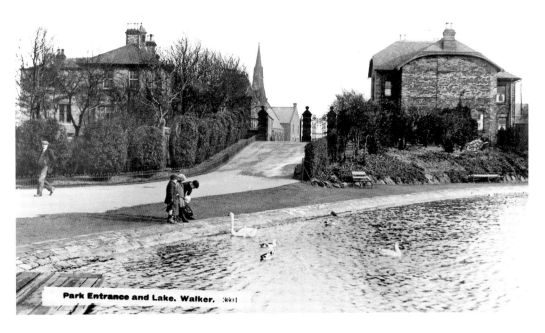

Park Entrance and Lake. Walker. 3601

Walker Park, Entrance and Pond

This image shows Walker Park entrance from the east side illustrating the well-kept and neat hedgerows and shrubs along with the old lake. Nowadays you can hardly see anything for the overgrown trees and as for the lake, well, that's long gone now. The park gates and bollards can be seen on both images, with the inset image illustrating the 'lodge' that cannot be seen from this angle nowadays because of the trees. (Old image courtesy of Newcastle Libraries and Information Service)

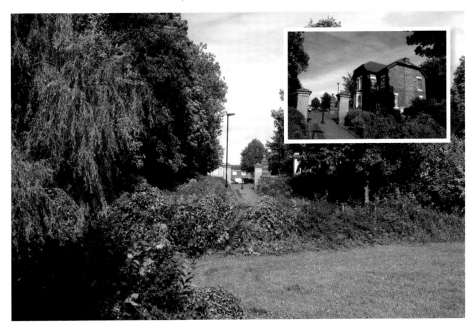

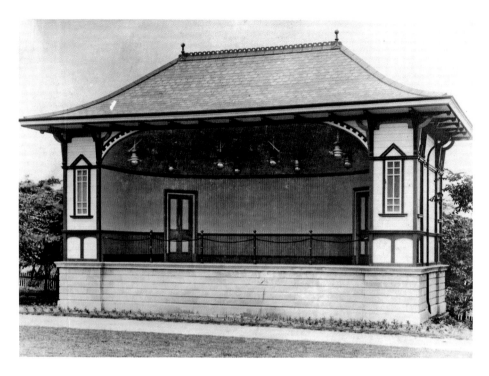

Bandstand, Walker Park

Lost in the sands of time (demolished in the 1960s), this bandstand would have been the hub of Walker Park back in '40s and '50s, maybe even prior to that. Nowadays, bowling clubs and other such activities reign at the park along with play parks for children and nice walks through its beautiful scenery of course. (Old image courtesy of Newcastle Libraries and Information Service)

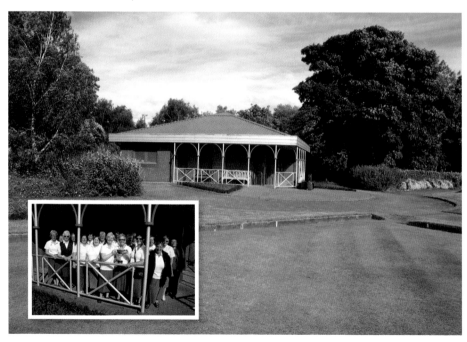

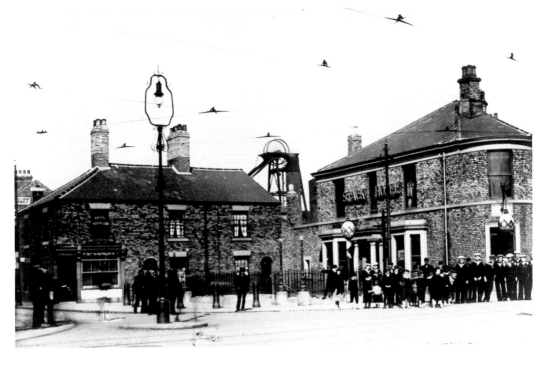

The Stack, Low Walker

Middle-aged readers may remember the Stack pub which was situated on the far left of the new image, just out of shot, but the even older generation may remember the *original* Stack public house when it stood behind the bus stop on the corner of Walker Road and Church Street. Both Stack pubs are now gone, confined to the realms of history. (Old image courtesy of Newcastle Libraries and Information Service)

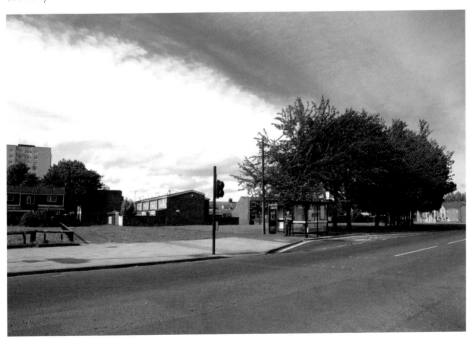

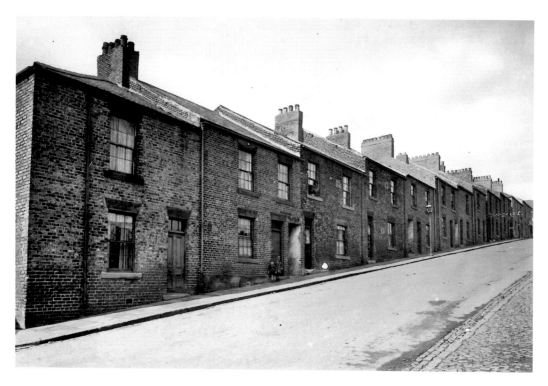

Belmont Bank, Walker

Nothing much has changed over the years here on Belmont Bank, apart from the addition of gardens for each abode and a new road surface. (Old image courtesy of Newcastle Libraries and Information Service)

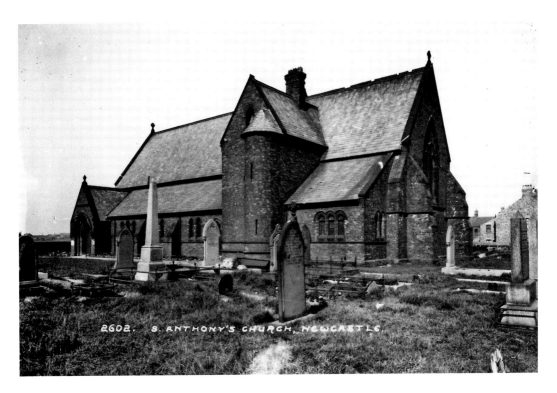

St Anthony's Church

I remember the excitement when a girl from my infant school got really upset after claiming to see a witch in the grounds of the old ruined church; of course then the church was in use. The removal of graves and headstones turned this one time graveyard into a makeshift playing field and a footpath running from St Anthony's Walk. A single gravestone remains (inset) dedicated to those that lost their lives during the Second World War. (Old image courtesy of Newcastle Libraries and Information Service)

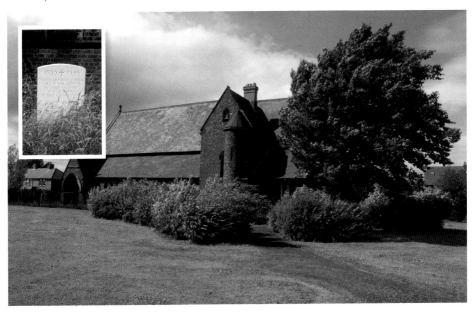

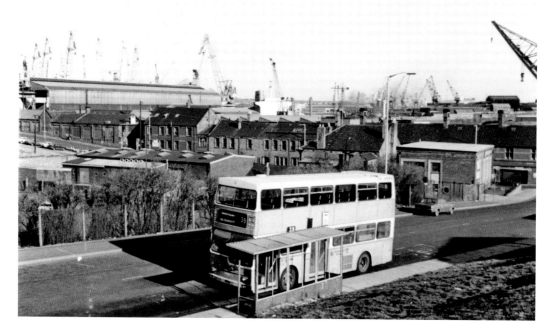

Welbeck Road & Swan Hunters

An old 39 bus waits for passengers at the bottom of Welbeck Road, Low Walker. Swan Hunter cranes and buildings in the background have now been dismantled and demolished, although nowadays you can't see this for the trees that have grown over the years. (Old image courtesy of Walter Ritson)

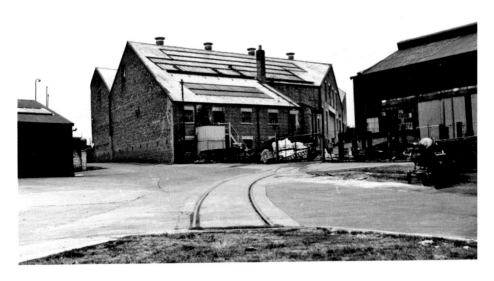

Hawthorn Leslie, the Foundry

The West Gate of the one-time ship building and locomotive parts manufacturer Hawthorn Leslie, established 1817, which once stood here for many years, housed this edifice known as the woodwork shop. Hawthorn Leslie closed for business in the early 1980s and was demolished sometime after. This Jewson warehouse now occupies the site of the woodwork shop. (Old image courtesy of Walter Ritson)

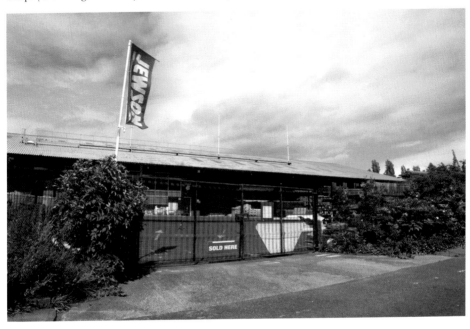

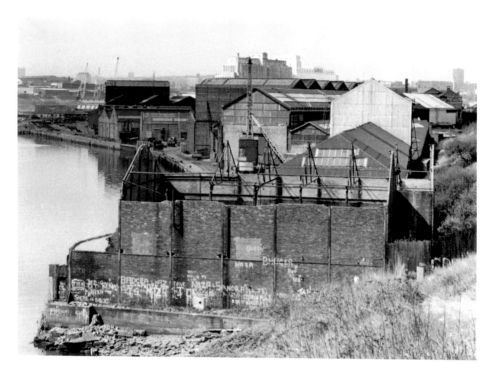

Hawthorn Leslie from the East

The old image was taken from the Riverside Line – now Hadrian's Way – back in 1978 and shows the majority of the Hawthorn Leslie site. From this very viewpoint *these* days nothing but high trees and stone steps that lead down to St Peter's Basin, which now occupies the site, can be seen. I have, therefore, taken the modern picture from down by the river showing what stands here today. (Old image courtesy of Walter Ritson)

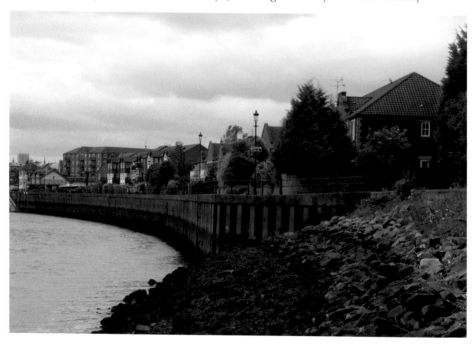

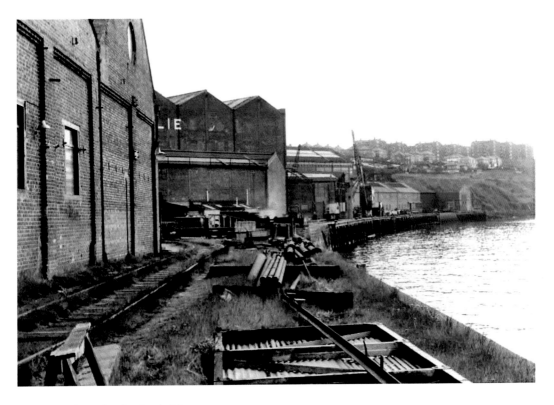

Hawthorn Leslie, Dockside

The rear of the 'Copper Shop' at Hawthorn Leslie's also showing the Oval and Mcutcheon Court in the background right, from around 1977. The houses in the Oval, and the actual river, are the only things that remain today. The lavish St Peter's Marina housing estate occupies the site now – what a difference. (Old image courtesy of Walter Ritson)

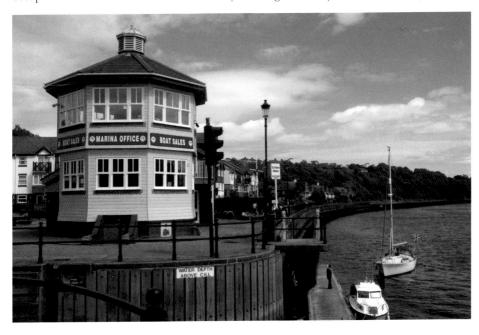

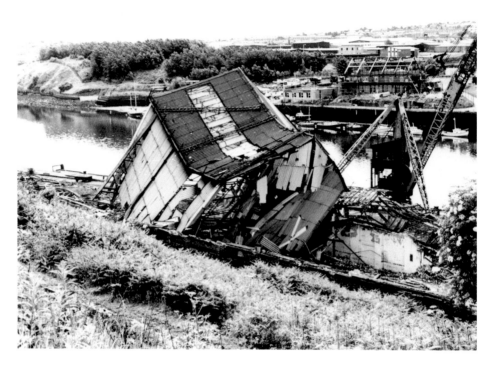

Hawthorn's Demise

The demolition of Hawthorn Leslie taken from the old railway known as the Riverside Line in Walker. My father worked at Hawthorn's for many years and documented many of the pictures you see in this book. Friars Goose boating club on the other side of the water can be seen in the background of both pictures. (Old image courtesy of Walter Ritson)

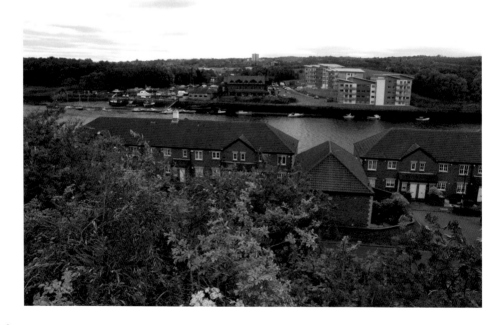

The Lodge, Hawthorn Leslie
The old picture was taken in 1975 and shows the 'lodge' on the site of Hawthorn Leslie. It's hard to imagine in the new image just where the lodge stood, so I will tell you. It stood roughly at the back, to the right of the house and up in the trees, and again, the difference is astronomical. (Old image courtesy of Walter Ritson)

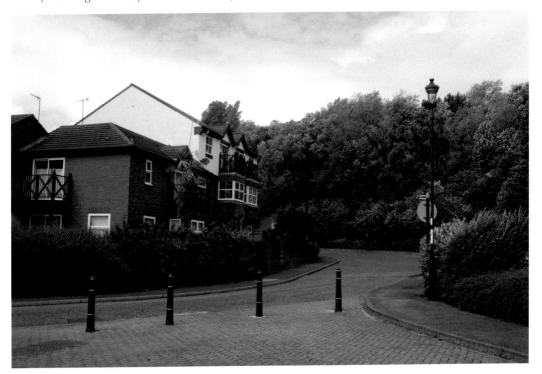

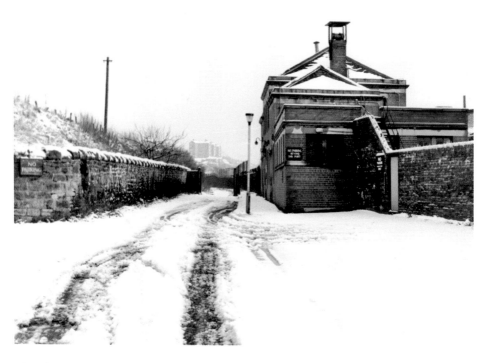

The Cherry Walk East, Walker

The building to the right of the old image is the aforementioned lodge from the top and rear. The old Cherry Walk heads east towards Mcutcheon Court with the Riverside Line atop of the embankment on the left. Nothing of this area remains today so the photographer's viewpoint was difficult to locate. I think that I have done the image justice, however, in the new modern version getting the best view possible. (Old image courtesy of Walter Ritson)

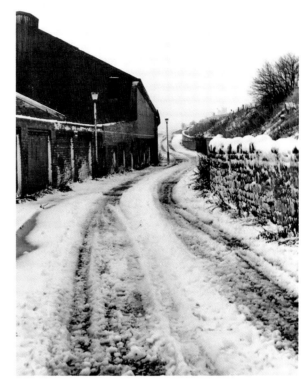

The Cherry Walk, West, Walker I
The buildings to the left are part of Hawthorn Leslie with the old Cherry Walk heading off west towards Newcastle Quayside. Again, nothing at all of this area remains today so the photographer's viewpoint was once again difficult to locate. The new image shows this area from the best possible place. (Old image courtesy of Walter Ritson)

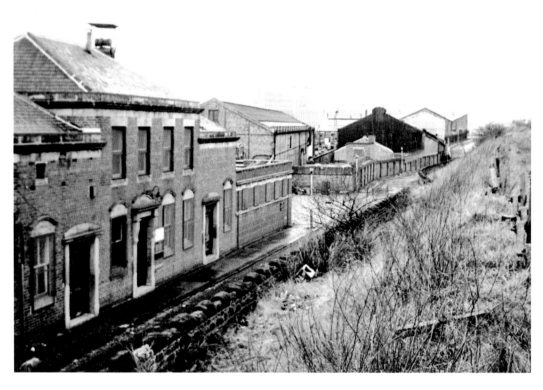

The Cherry Walk, West, Walker II
The same image as the last one only viewed from higher up on the railway lines. The newer image clearly illustrates the massive difference here between the years 1980 and 2012. (Old image courtesy of Walter Ritson)

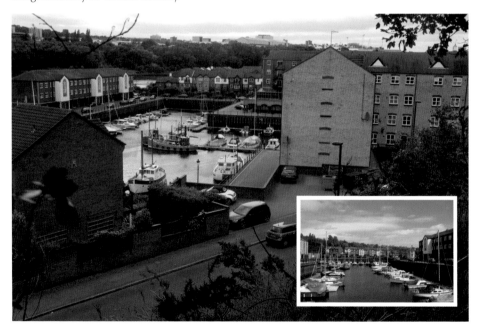

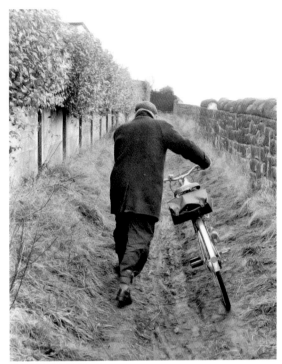

Cherry Walk East, Oval End

A Hawthorn Leslie employee makes his way home after a hard day's work. A short cut up through the Cherry Walk to the Oval made sure this chap got home in good time for his evening meal. The old wall on the right is long gone, and the muddy walkway has been replaced with a concrete path; apart from that nothing much has changed, really. (Old image courtesy of Walter Ritson)

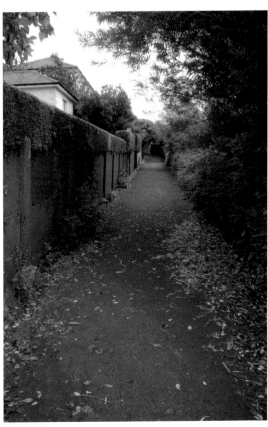

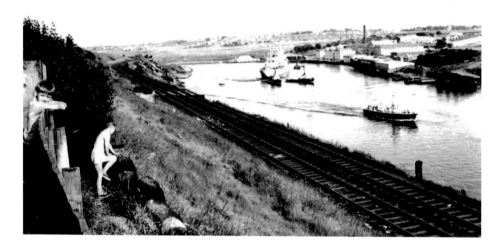

Riverside Line, Facing East

This picture shows the old railway line that ran past the author's old house in Walker. Indeed, the skinny little rascal climbing on the wall in the old image is in actual fact the author, with his older brother leaning against the fence, taken thirty-five years ago when the line was still in use. The new image shows the wall that I was climbing on, a bit of the River Tyne but nothing much else apart from trees. The inset image shows the old line today, known as Hadrian's Way. (Old image courtesy of Walter Ritson)

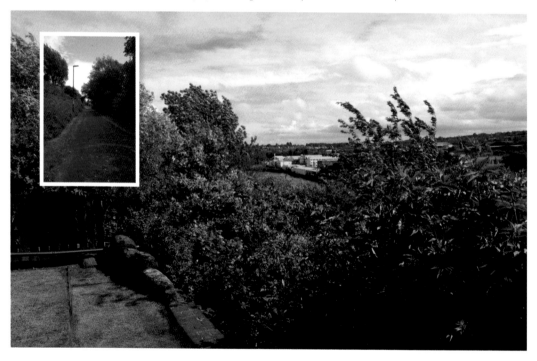

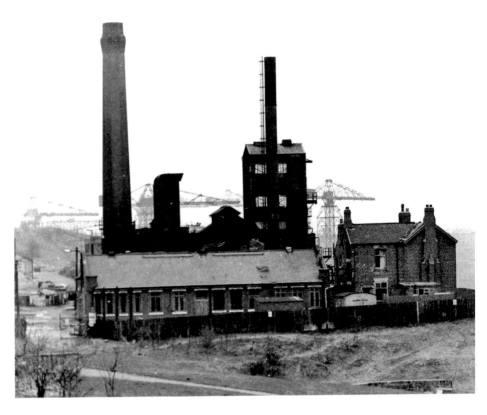

The Old Tar Works, Pottery Bank I
The Pottery Bank tar works back in the late 1960s. Public footpaths and the odd office block occupy the area now. (Old image courtesy of Walter Ritson)

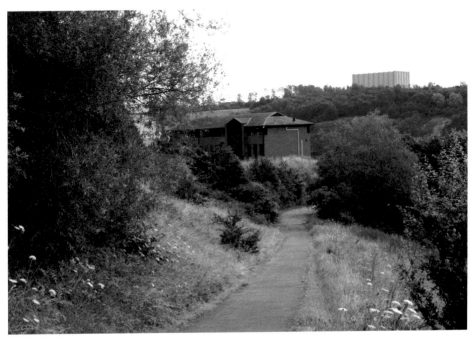

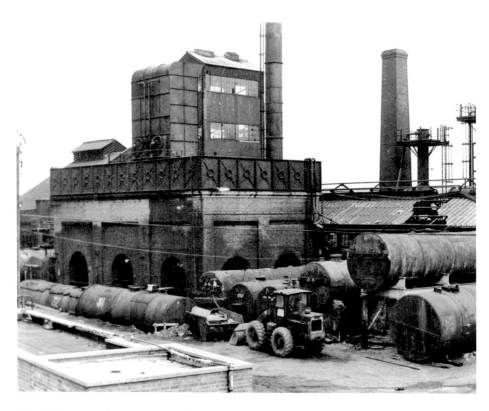

The Old Tar Works, Pottery Bank II
This particular area of the tar works is now a car park and field. (Old image courtesy of Walter Ritson)

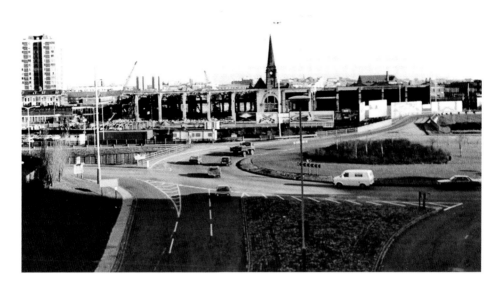

New Bridge Street, Newcastle

The building at the back of the image in the process of being demolished was the New Bridge Street Goods Station. This area was bombed by the Germans in the Second World War back in September 1941. In more recent years the old Warner Bros. Cinema complex occupied this site before it was demolished to make way for the Northumbria University buildings. (Old image courtesy of Walter Ritson)

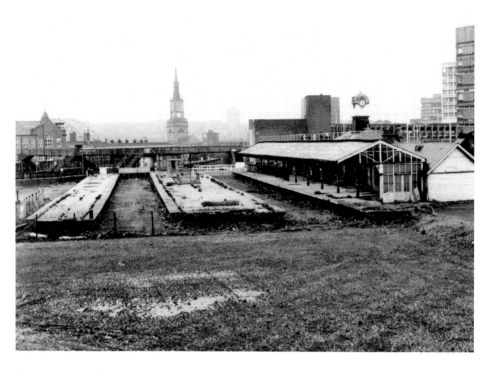

Manors North, Newcastle

This old station was known as 'Manors North' and was owned by the North Eastern Railway Company. The station closed to passengers around 1978, just a year or two before this picture was taken. A scene from the movie *Get Carter* staring Sir Michael Caine was filmed here in 1971. Nowadays, the site houses the ultramodern Technopole Business Park. (Old image courtesy of Walter Ritson)

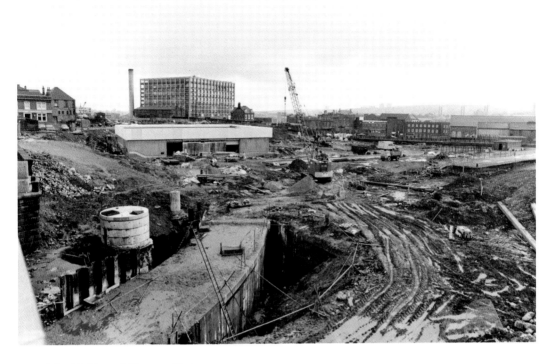

The Making of Manors Metro

Manors Metro station and the Metro system itself being constructed in the late 1970s. Manors Metro station actually opened in 1982, so there was still a fair bit of work to be done at this point. The modern image shows the station in its full glory alongside the car park and buildings of the Technopole Business Park. (Old image courtesy of Walter Ritson)

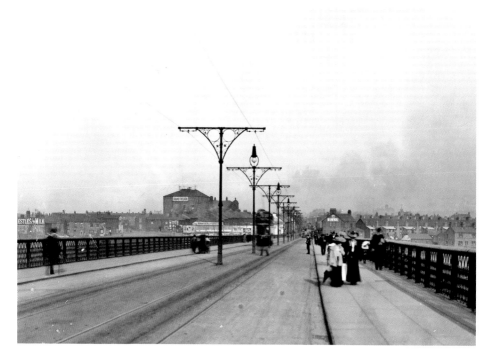

Byker Bridge, Byker

The bridge was constructed in the late 1800s and was officially opened to pedestrians by the vice chairman of the Byker Bridge Company on 19 October 1878. On 27 January 1879 it was opened to carriages and horse carts with a road toll of just half a penny. The toll was abandoned in 1895. Buses, cars, lorries and trucks all use the road now to get in and out of Newcastle City Centre from the east. (Old image courtesy of Newcastle Libraries and Information Service)

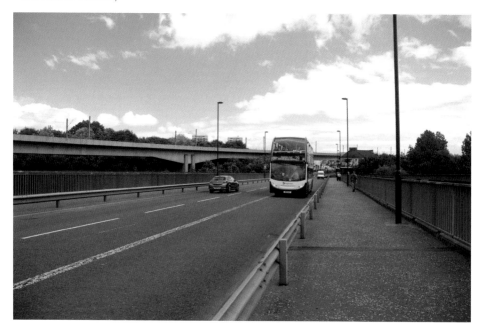

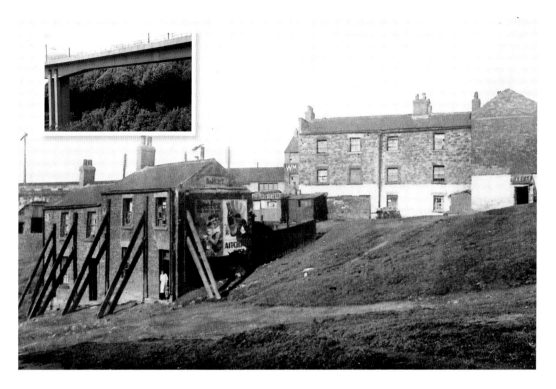

Appleton's Builders, Near Byker Bridge

I have used two images to show roughly whereabouts these old buildings once stood. The inset image shows Byker Bridge and the trees underneath, illustrating where it was, and then I have also used an image of a nearby pub called the Cumberland Arms which is a stone's throw away from the area concerned. (Old image courtesy of Newcastle Libraries and Information Service)

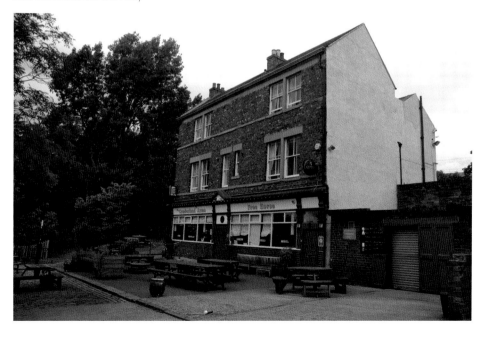

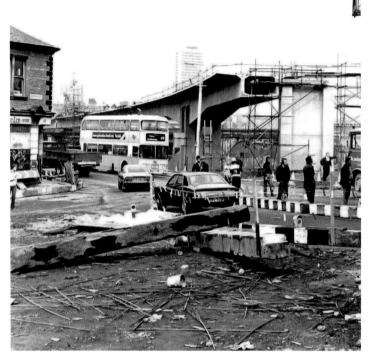

The Metro Bridge, Shields Road I

To link Newcastle with Newcastle East a metro bridge needed to be built across the Ouseburn Viaduct and so it was. Running virtually parallel to Byker Bridge the Metro Bridge was built in the late 1970s and opened in 1982; the stretch of line is known as the St James to Tynemouth line. Here the bridge is being constructed over the bottom of Shields Road. (Old image courtesy of Walter Ritson)

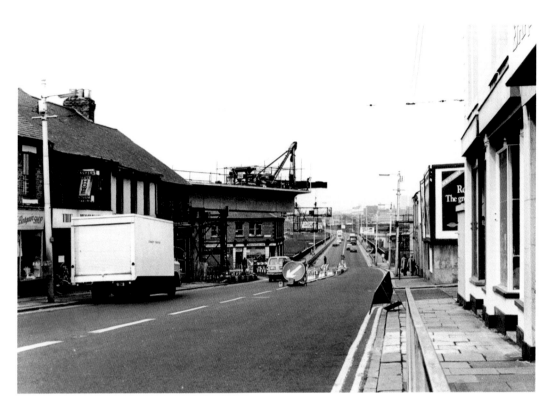

The Metro Bridge, Shields Road II
A similar image to the previous one only from a different angle. On the modern images we see the bridge in its full glory over the bottom of Shields Road. (Old image courtesy of Walter Ritson)

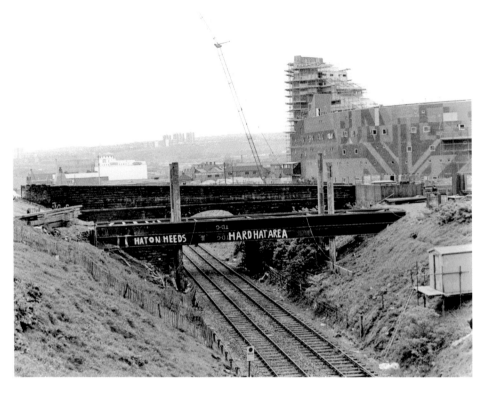

Riverside Line North, Byker I

This old image from 1975 shows the Riverside Line as it turned north from Spillers Mill (the white building seen in the background) and headed into Byker. The line opened in 1901 and closed in 1979. These days, it's a section of Hadrian's Way. Note the construction of the infamous 'Byker Wall' to the rear right. (Old image courtesy of Walter Ritson)

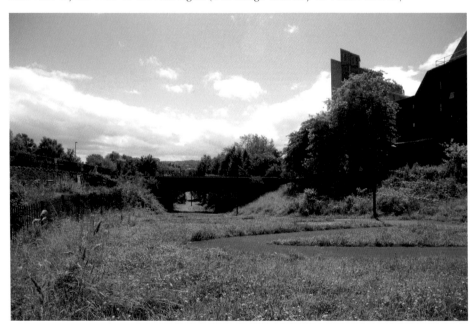

Riverside Line North, Byker II

This image shows the same area from the south. The Metro Bridge can be seen spanning the rear of the image as can a section of the Byker Wall housing estate with the long gone allotments in the foreground left. (Old image courtesy of Walter Ritson)

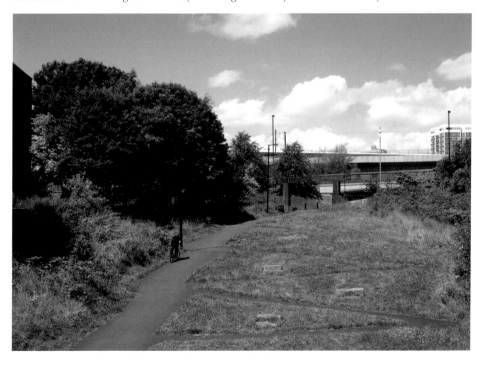

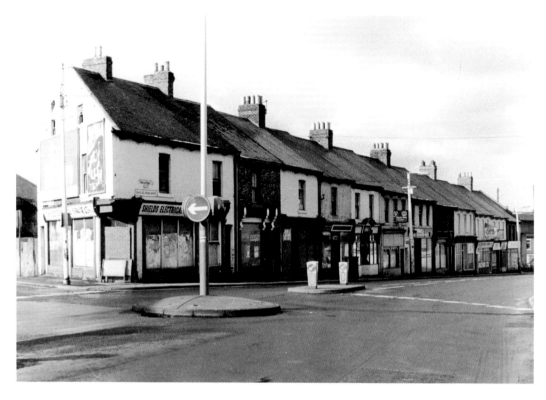

Shields Road, Near Morrison's

These houses and stores once stood at the bottom of Shields Road. To the extreme right you can just see the Metro Bridge as it makes its way over the road. Nowadays, a filling station occupies the site. (Old image courtesy of Walter Ritson)

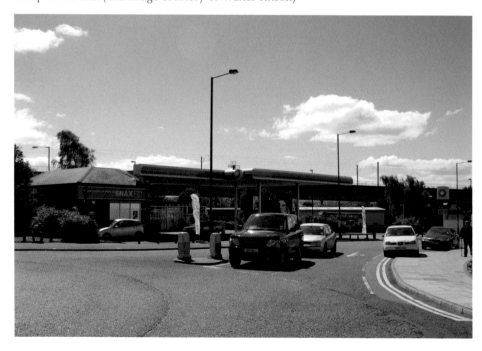

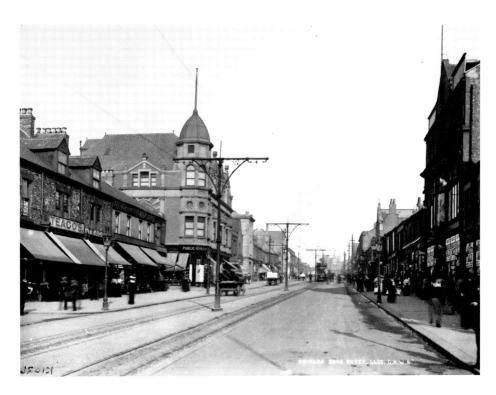

Shields Roads, Near Brinkburn Street

This old image of Shields Road dates from around 1910. The building with the domed roof was once the Masonic Lodge. From trams and carts to buses and cars Shields Road nowadays is a traffic nightmare. Although the Shields Road bypass has helped the situation. (Old image courtesy of Newcastle Libraries and Information Service)

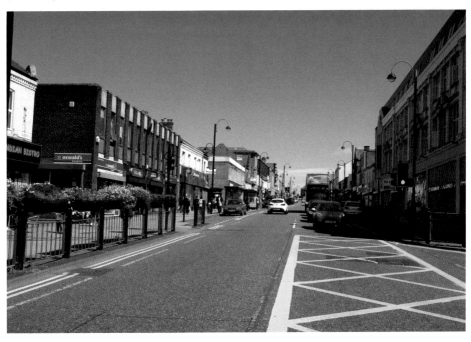

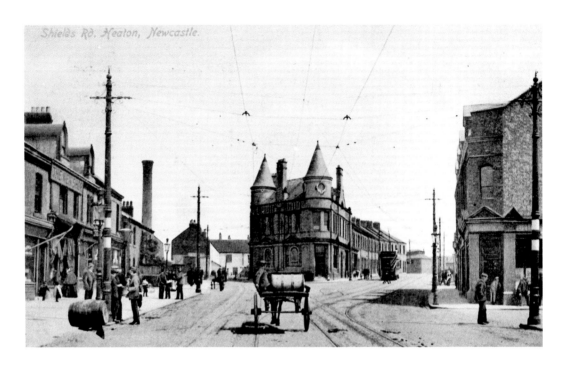

Shields Rd. Heaton, Newcastle.

The Blue Bell, Shields Road

The building at the centre rear was a public house; when I was a nipper it was known as the Blue Bell. In the early 1980s it became a bike shop and still is to this day, although the houses that run behind it have now been knocked down. The Byker and Heaton Social Club stands to the right and shops and stores take up the left hand side of the road. (Old image courtesy of Newcastle Libraries and Information Service)

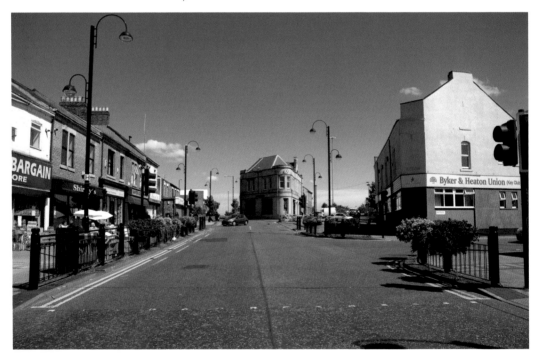

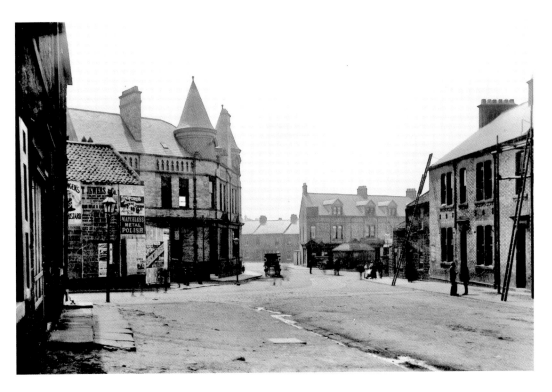

Shields Road, the Lord Clyde Pub

This view of the top of Shields Road from near the old cinema shows the old Blue Bell with its two coned roofs. The buildings on the right have been transformed into ale houses and offices. The pub was formerly called the Lord Clyde Hotel but is now known as Peggy Sue's Bar. (Old image courtesy of Newcastle Libraries and Information Service)

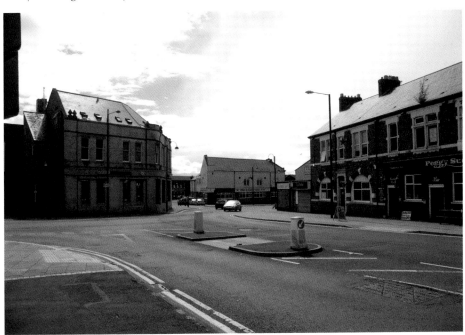

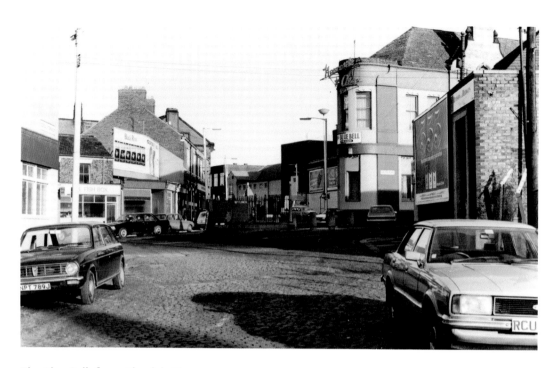

The Blue Bell, from Glendale Terrace

Taken in 1978 this image shows the same view as the prior photograph from the opposite angle. Ron's Gymnasium on the extreme right of the old image is long gone, relocated next to Byker Metro, and the public lavatories that stood in front of the Blue Bell pub have also been lost to time. (Old image courtesy of Walter Ritson)

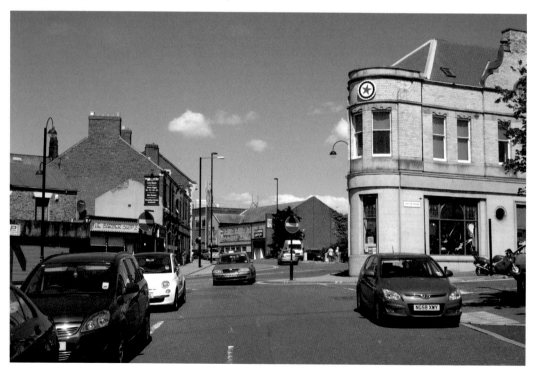

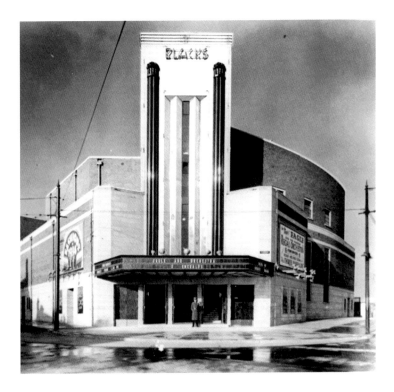

Black's Regal Cinema, Shields Road

Black's Regal Cinema was its original name in the 1940s before it became the Odeon Cinema. Its stood at the top of Shields Road and served the good people of Byker and Walker for many years before being knocked down to make room for a filling station, which can be seen in the modern image. (Old image courtesy of Newcastle Libraries and Information Service)

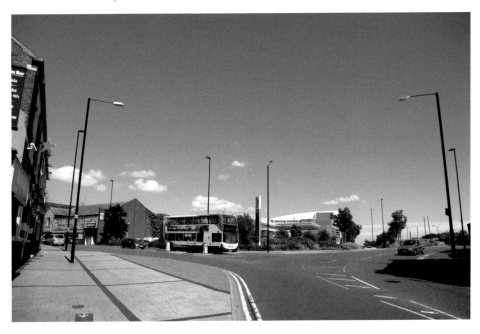

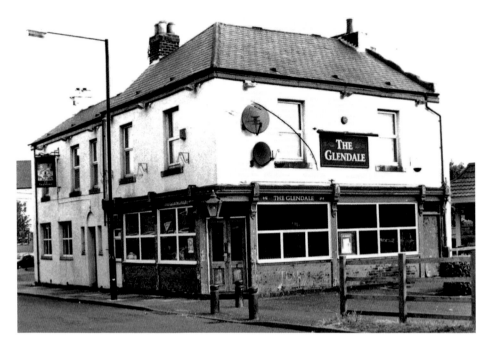

The Glendale Pub, Potts Street

This building, I think, was not that old but has still become a part of Byker's history. After it stood derelict for a few years Gorman's fish and chip shop took it over and gave it a new lease of life. I remember my early days of frequenting public houses back in the late 1980s/early 1990s when I often used to come here and down a few pints of Stones Bitter – happy days. I must visit Gorman's sometime and have myself a fish supper! (Old image courtesy of Walter Ritson)

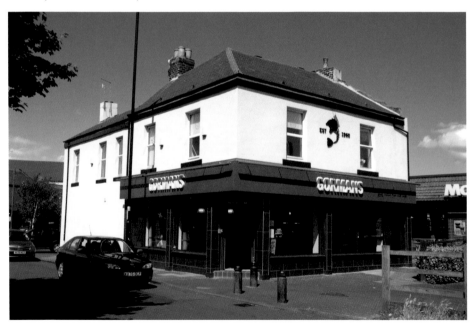

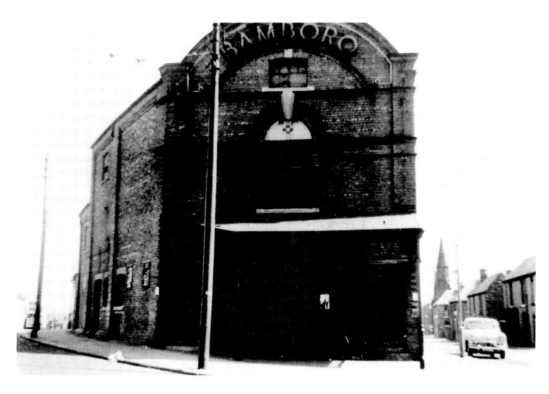

The Bamboro Picture House, Union Road
The old Bamboro Picture House once stood on the site of the Newcastle East Community Fire Station. I am not too sure when it stood here but I can surmise it was long before the Black's Regal and the Odeon Cinema that stood over the road. The fire station opened in 2005 and is currently staffed by forty-eight fulltime fire fighters. (Old image courtesy of Newcastle Libraries and Information Service)

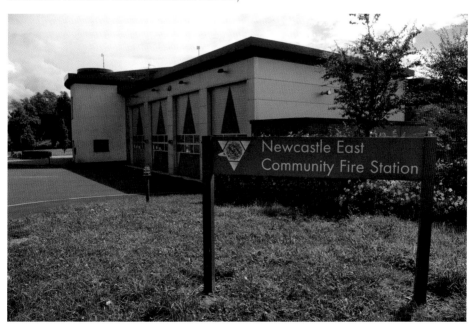

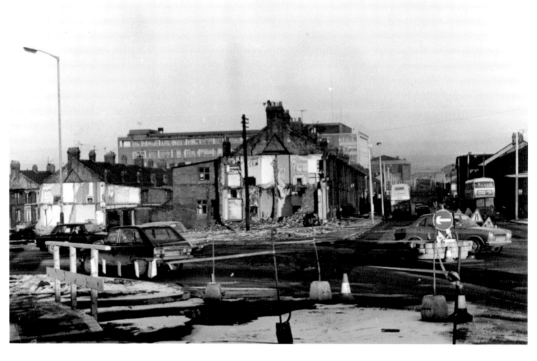

Shields Road Meets Chillingham Road

Back in the 1970s this place was a demolition site with properties coming down left, right and centre. The buildings at the rear left of the image being replaced with Metro lines which now run under the main road while Parsons factory in the background centre can be seen to this day. (Old picture courtesy of Walter Ritson)

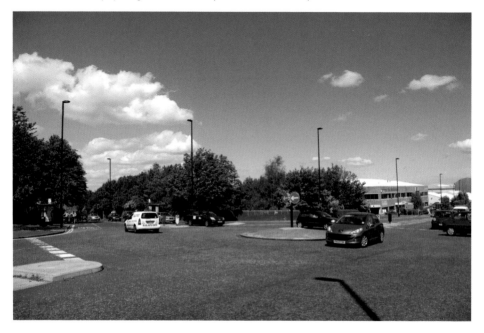

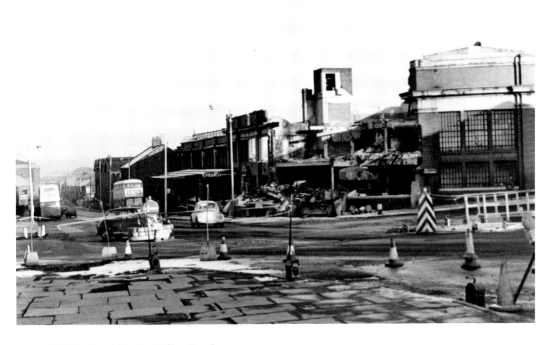

Shields Road Meets Miller Road

Giving way for the Metro system, these buildings were also 'marked for death' and subsequently demolished to make way for the new. The PTE Social Club can be seen in the new image, but a little dickie bird tells me that this fine establishment has also been recently marked for demolition. Oddly, however, it is to be rebuilt only metres away on the site of the car wash that is also featured in the picture – you couldn't make it up. (Old picture courtesy of Walter Ritson)

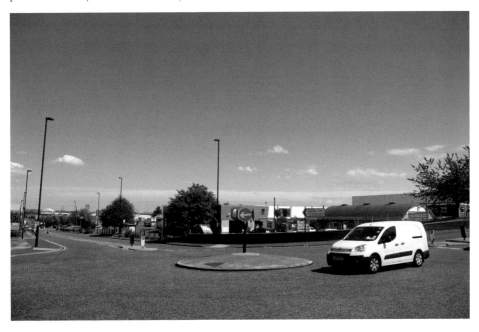

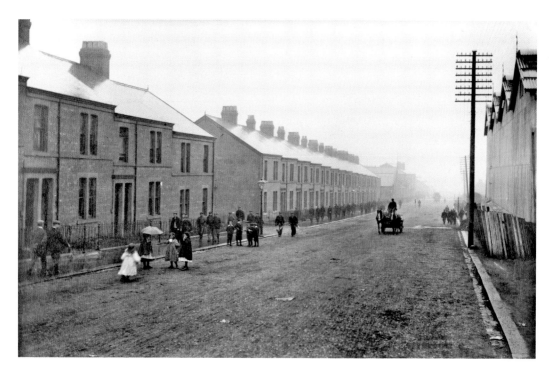

The Fossway, West End

The Fossway west, *c.* 1915. Most of the houses down this stretch of road were long demolished and replaced with industry. Parsons Engineering, the one-time largest employer on Tyneside, was built here as well as the sports venue Brough Park, which hosted events such as speedway and dog racing. (Old image courtesy of Newcastle Libraries and Information Service)

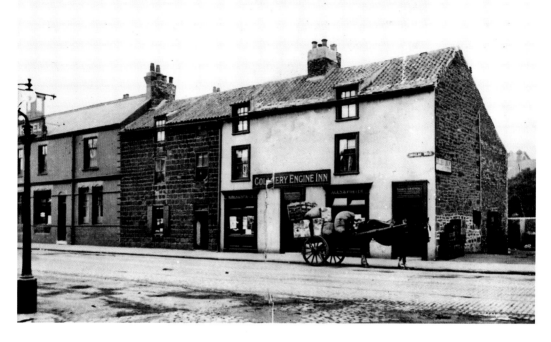

The Colliery Tavern, near Benfield Road

The pub that occupies the site nowadays is known as the Woolsington Hotel and was built on the site of another pub that was demolished in the early 1970s called the Colliery Tavern. (Old image courtesy of Newcastle Libraries and Information Service)

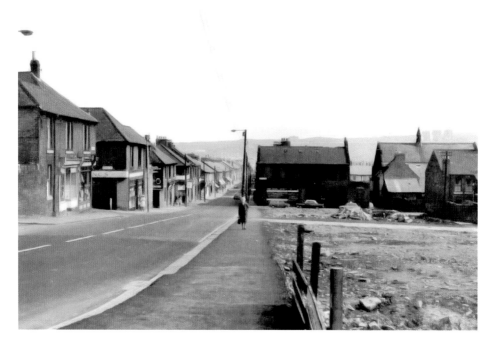

Raby Street – South

Looking south down Raby Street in Byker towards Commercial Road in the 1970s. The houses and shops on the old image have since been replaced with newer modern buildings. The street itself nowadays has been altered in such a way to reduce the amount of traffic so the road is not as busy as it once was. (Old image courtesy of Walter Ritson)

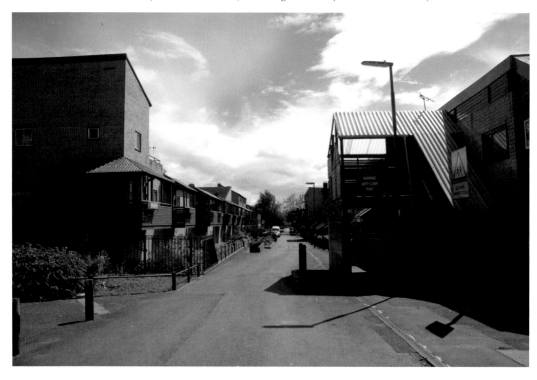

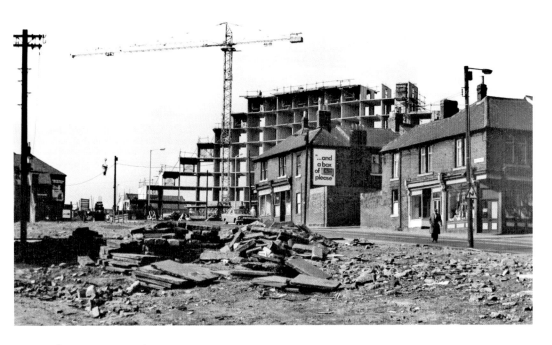

Raby Street – North

Looking north up Raby Street this time to the construction of the infamous Byker Wall in the mid-1970s. The Byker Wall is a long, very high and unbroken block of flats that loop around and through Byker itself. Most, if not all, of the old image is long gone and looks entirely different, as the newer image depicts. (Old image courtesy of Walter Ritson)

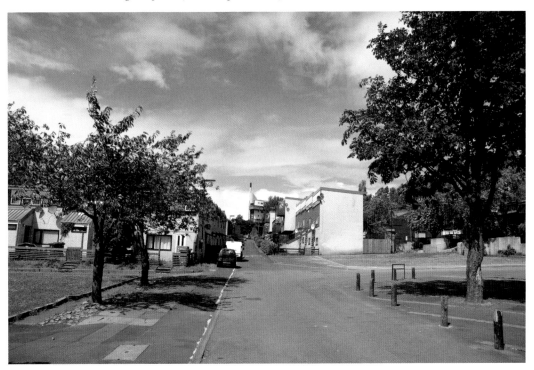

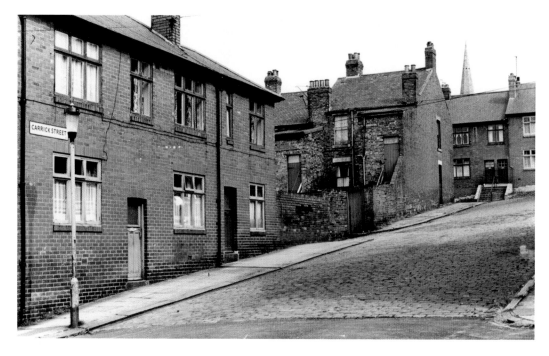

Carrack Street, Byker

The birthplace of my father; in fact the house he was born in can be seen in this old image. The area has changed considerably over the years with the houses being demolished and the cobbled road being completely transformed altogether. The new image was taken in the exact spot as the old one (one the site of the old Oban Road) and you can use the church steeple in the background of both images as a reference point. (Old image courtesy of Walter Ritson)

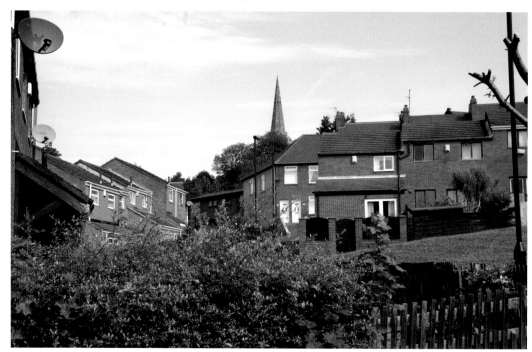

Commercial Road, Raby Way
Where Commercial Road meets Raby Way, Byker. Commercial Road is heading straight up the bank to Walker, with Raby Way heading off to the left. (Old image courtesy of Walter Ritson)

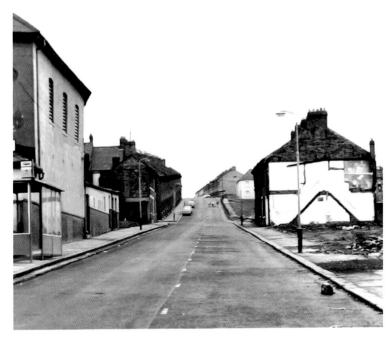

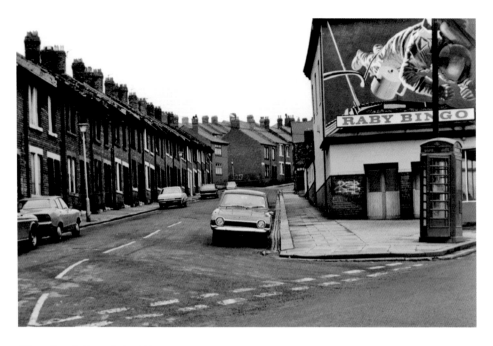

Oban Road, Now Raby Way

The road in the old image ran diagonally through the telephone box in the new image so these two roads are not one and the same. The old road was named Oban Road and the new road is known as Raby Way. The Raby Bingo in the old image was demolished and would have stood in the extreme right of the new picture. One other interesting note is that the old car parked next to the Raby Bingo was my father's; he parked there to take the picture. The car in the new picture is the author's and it was also parked there for the picture. Essentially, it's the same image taken by father and son almost forty years apart. (Old image courtesy of Walter Ritson)

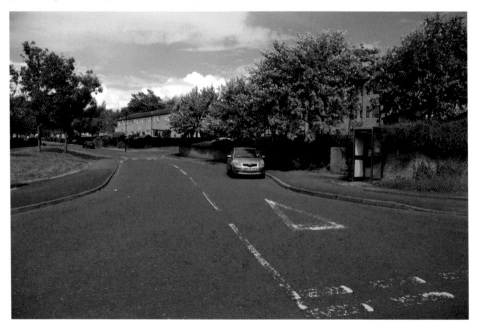

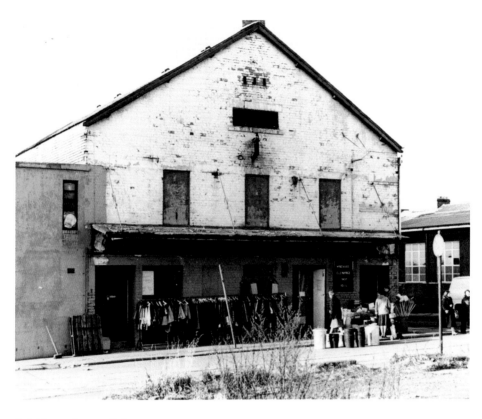

Brinkburn Street, Byker

The old image shows an unused picture house on the corner of Brinkburn Street and Clifford Street being used as an old clothes shop in the early 1970s. It was knocked down in later years to make way for the Byker Job Centre. (Old image courtesy of Walter Ritson)

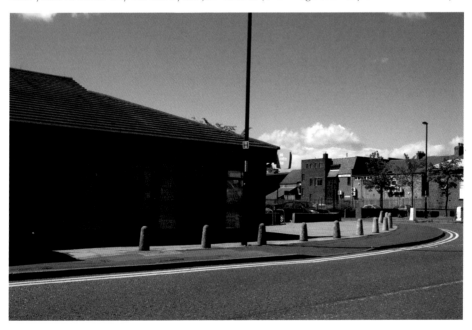

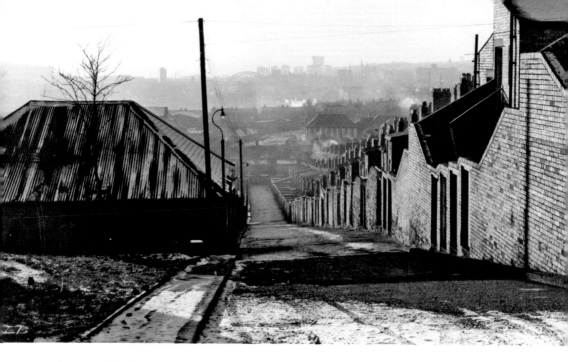

Back Lanes of Byker, St Peter's Road
This is one of my favourite photographs from my father's collection taken from St Peter's Road and shows one of the many back lanes in Byker as it sweeps down and away overlooking the City of Newcastle. I tried to capture the same magic and atmosphere in my picture but sadly failed miserably. (Old image courtesy of Walter Ritson)

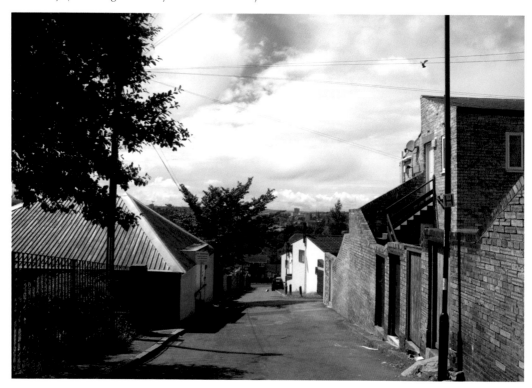

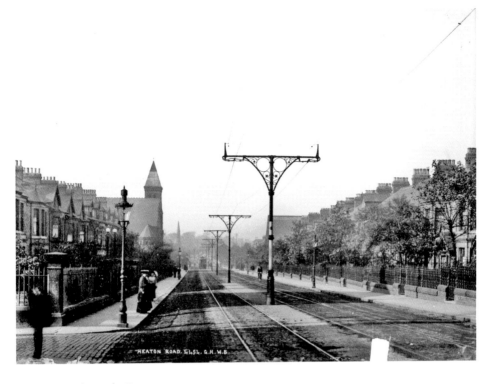

Heaton Road South, Heaton

The differences on this image are plain to see. The church on the left hand side of the old image, *c.* 1900, was taken down many years ago although there is another modern church nowadays known as the Elm Pentecostal Church which can be seen to the left of the newer image. Most of the houses are gone and have been replaced with offices and such like. (Old image courtesy of Newcastle Libraries and Information Service)

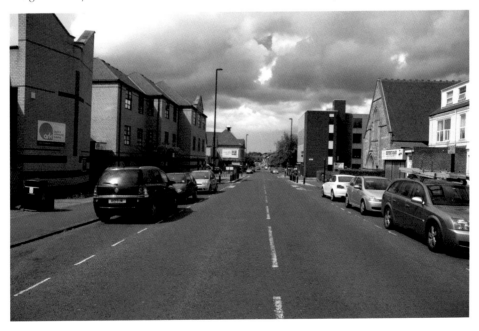

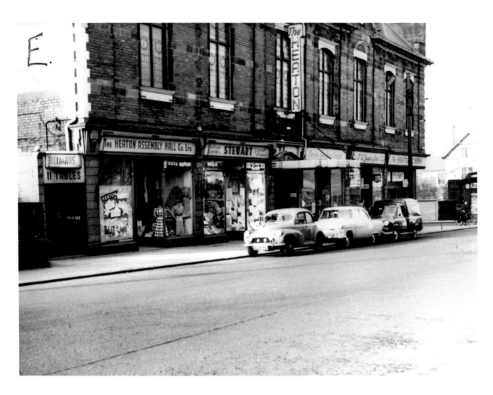

The Heaton Cinema, Heaton Road

Standing on Heaton Road where it meets Denmark Street is the old Heaton Assembly Buildings and Pool Hall. This building was converted into a bingo hall and social club where my mother worked for many years. (Old image courtesy of Newcastle Libraries and Information Service)

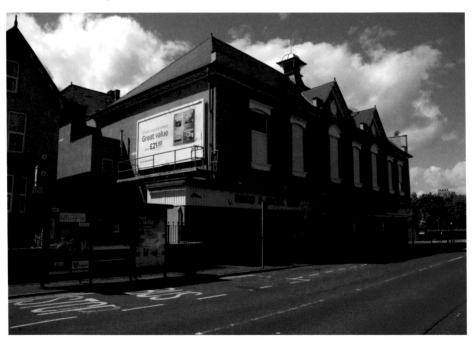

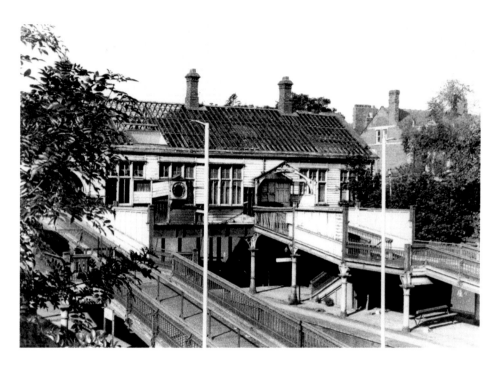

Heaton Railway Station

I am not sure which of the two train stations this one is as there have been two along this stretch of track, one 'overlapping' the other by all accounts. If I had to guess I would say this was station number *two* that was opened in 1887 and closed in 1980. The old wooden structure served the North Shields Line in its heyday which was electrified in 1904. The building stood until around 1974 and then it was dismantled. However, the platforms stayed open until 1980, eventually being put out of use when the Metro system was built. The new image shows where the station once stood. (Old image courtesy of Walter Ritson)

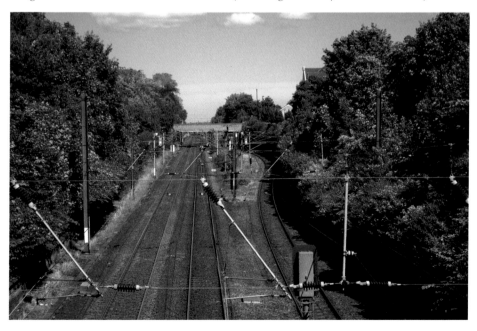

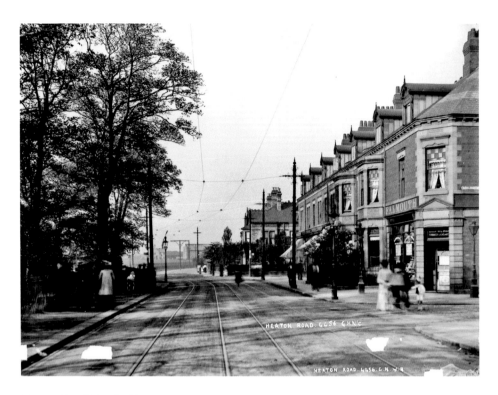

Heaton Road North, Heaton

Heaton Road South near the entrance to Heaton Park. The only thing that remains the same in this image is the façade on the restaurant called the Butterfly Cabinet to the right of the image. The road to the right, King John Street, is now blocked off to cars and vehicles. (Old image courtesy of Newcastle Libraries and Information Service)

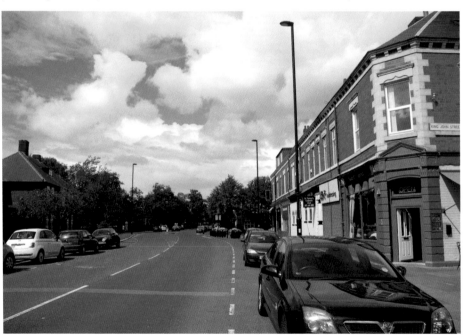

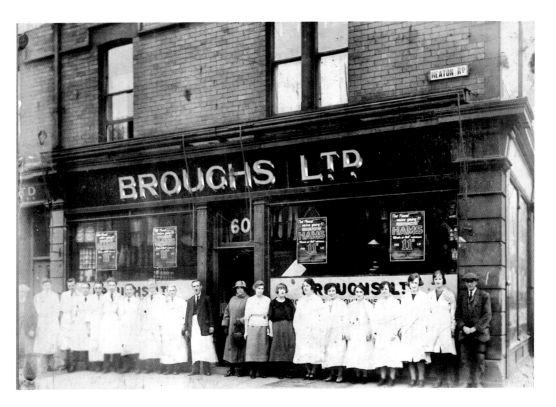

Broughs Ltd, Heaton Road

Broughs Ltd in 1924, as the shop staff line up for a picture. It's amazing to think just how many individuals worked in one shop back in those days. Today it is a newsagent with only two or three people working there. (Old image courtesy of Newcastle Libraries and Information Service)

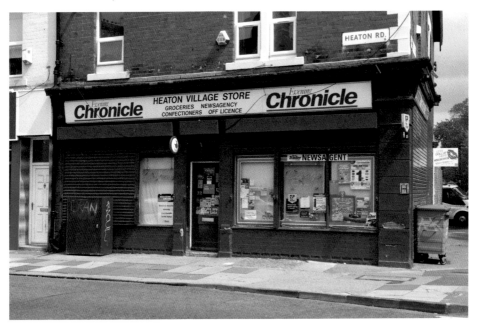

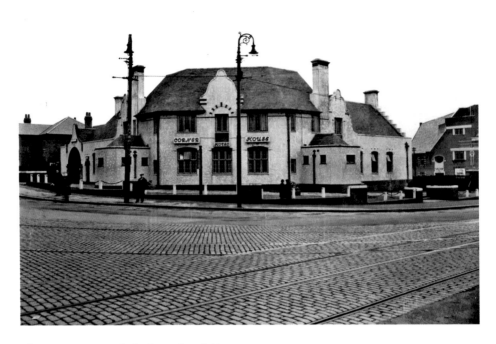

The Corner House Pub, Coast Road, Heaton

In 1936 the roads were cobbled and were adorned in tramlines. Nowadays this is the busy Coast Road that runs into Newcastle from Tynemouth, so the pub is located in an ideal place. The pub, with a hotel at the rear, was built in the early 1930s and was designed by Scottish architects C. T. Marshall and W. Tweedy. Today it is still a public house and hotel and a thriving one at that. (Old image courtesy of Newcastle Libraries and Information Service)

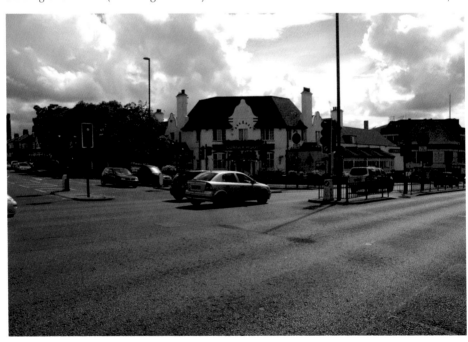

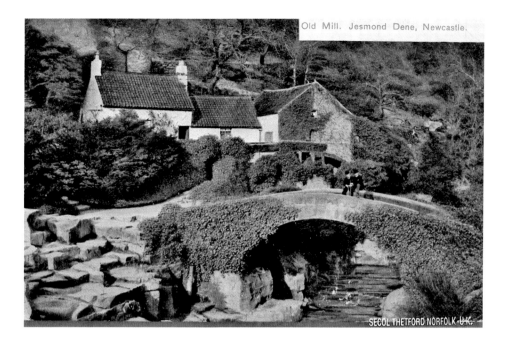

SECOL THETFORD NORFOLK U.K.

The Old Millhouse, Jesmond Dene

The Mill at Jesmond Dene is a rather significant part of Tyneside's industrial heritage and dates to the early nineteenth century. It is thought an earlier mill may have stood on the site of this one with this building being repaired and restored on a number of occasions. The old image dating from around the late 1800s shows two well-dressed gentleman sitting on the stone bridge in front of the house; perhaps they were the tenants of the mill house at that time. Nowadays, you can hardly see the ruin due to overgrown trees and bushes. (Old image courtesy of Newcastle Libraries and Information Service)

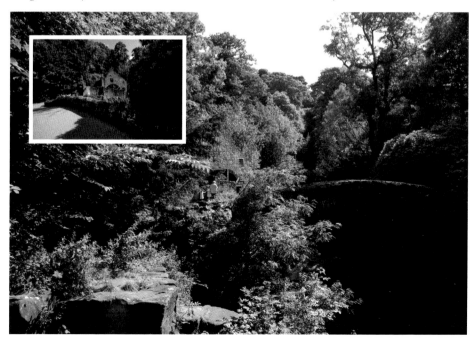

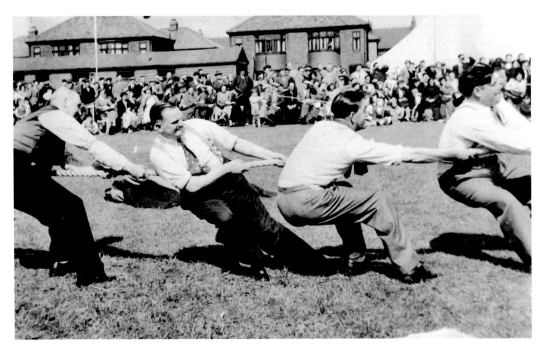

Tug of War
Sports day back in 1956 with Bill Laws, Jack Bower, H. Henderson and D. McCluskey from Hawthorn Leslie. Today this field is often used for football matches on a Sunday morning. The shed behind the crowd is gone but the houses in the background with the rounded window bays still remain. (Old image courtesy of Jean Ritson)

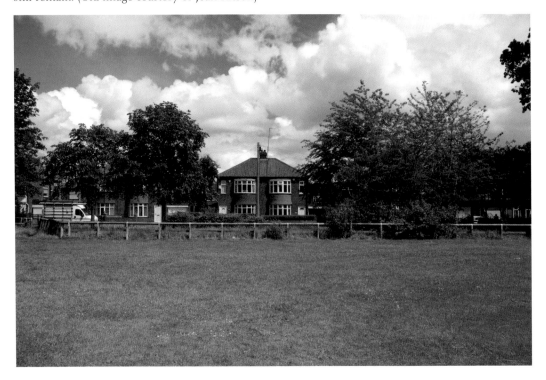

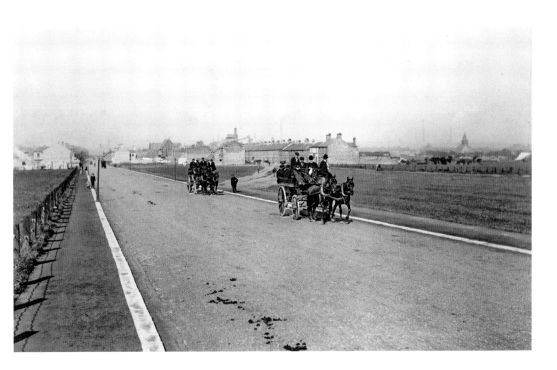

Welbeck Road, Walker

The old image shows horses and carts being used for transport on a road which houses no houses. The buildings in the background, to the right, would be the spot where my senior school stood; sadly that was demolished in 2011/12. Over one hundred years later the picture is very different. (Old image courtesy of Newcastle Libraries and Information Service)

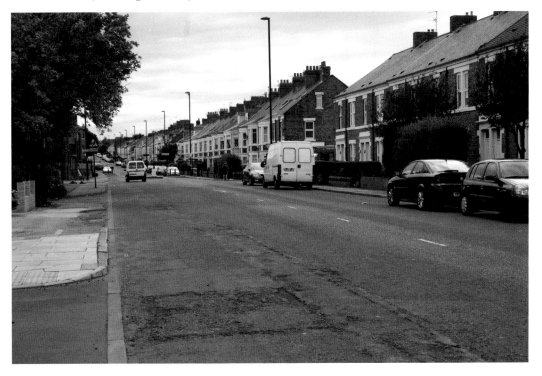

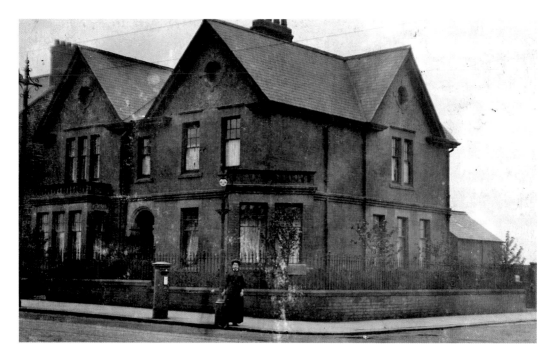

Welbeck Road, Scrogg Road Junction I

When I was younger the building in this picture was my dental practice until his move across the road. The building to the right of main building was a pharmacy. Nowadays, it stands ruined but there are plans to transform this old Victorian abode into modern flats. (Old image courtesy of Newcastle Libraries and Information Service)

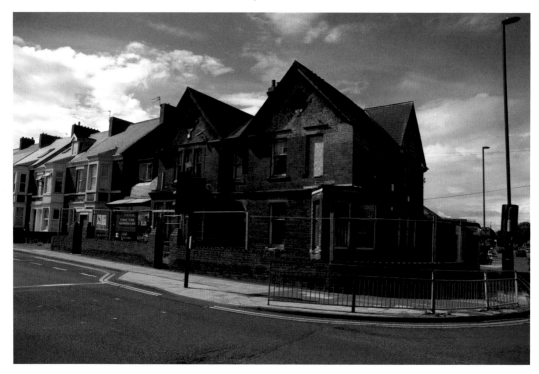

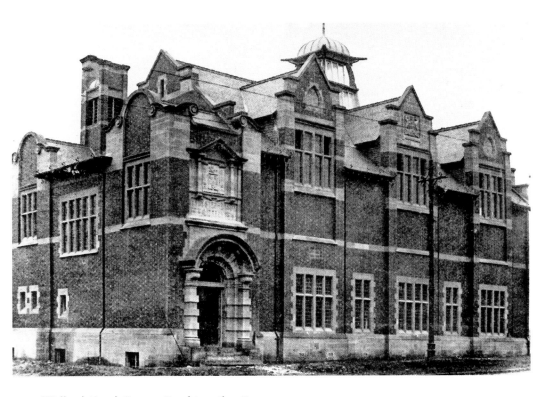

Welbeck Road, Scrogg Road Junction II
A view of the Walker Library building in the early 1900s and below in 2012. (Old image courtesy of Newcastle Libraries and Information Service)

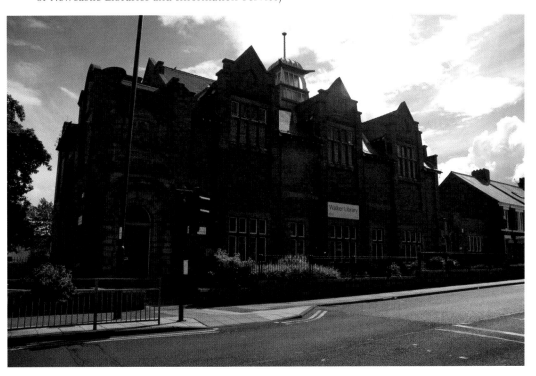

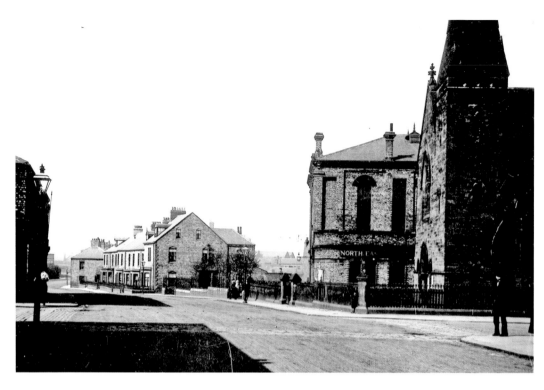

Church Street, Church Walk

These two images differ somewhat as no buildings in the old image stand today. A housing estate sits here now which leads to Church Walk Shopping Centre. (Old image courtesy of Newcastle Libraries and Information Service)

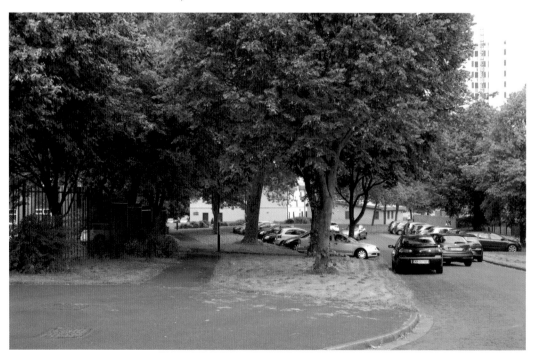

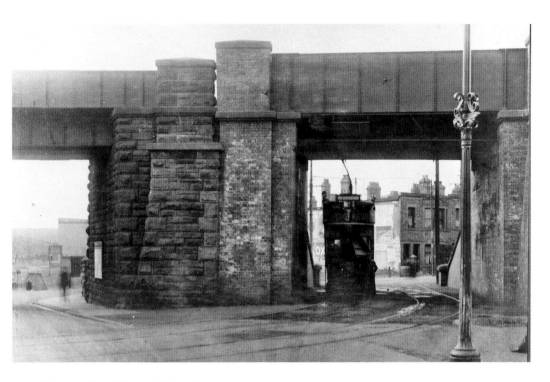

Neptune Road Meets Fisher Street

This photograph taken from Mill Road shows the underpass of the one-time railway bridge that once stood here. Had the bridge been still standing it would have been a part of Hadrian's Way which ends at Wallsend. Instead, walkers have to come down and cross the road before venturing back up on to the walkway. The old image shows a tram making its way to Low Walker whereas buses nowadays take this route. (Old image courtesy of Newcastle Libraries and Information Service)

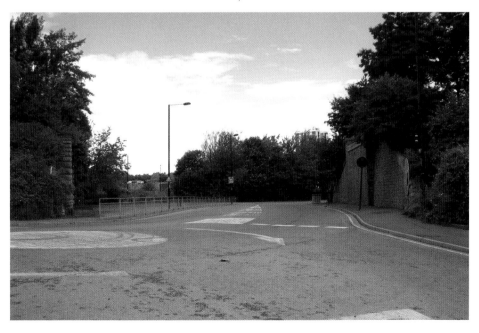

Books by the Same Author

Ghost Hunter – True life Encounters from the North East
In Search of Ghosts – Real Hauntings from Around Britain
The South Shields Poltergeist, One Family's Fight against an Invisible Intruder
 (With Michael J. Hallowell)
In Search of Ghosts – Real Hauntings from Around Britain
Haunted Newcastle
Ghost Taverns – An Illustrated Gazetteer of Haunted Pubs in the North East of
 England (With Michael J. Hallowell)
Paranormal North East
Supernatural North
Haunted Durham
Haunted Berwick
Ghosts at Christmas
The Haunting of Willington Mill (With Michael J. Hallowell)
Haunted Northumberland
Haunted Tyneside
Ghost Taverns of the North East (With Michael J. Hallowell)
Paranormal County Durham
Haunted Carlisle

Coming Soon – *Haunted Wearside*